IMAGES
of America

LOCKPORT

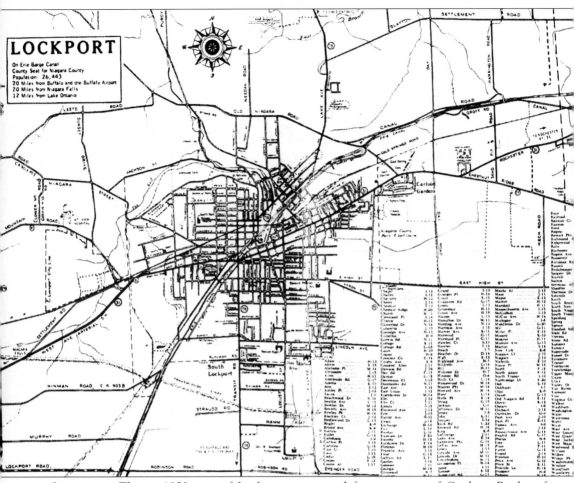

LOCKPORT. This *c.* 1950 map of Lockport was issued for customers of Cooksey Realty of Niagara Falls.

IMAGES
of America

LOCKPORT

Paulette Peca

ARCADIA

First printed in 2003.

Published by Arcadia Publishing,
an imprint of Tempus Publishing Inc.
2A Cumberland Street
Charleston, SC 29401

Printed in Great Britain.

Library of Congress Catalog Card Number: 2003104546

For all general information, contact Arcadia Publishing:
Telephone 843-853-2070
Fax 843-853-0044
E-mail sales@arcadiapublishing.com

For customer service and orders:
Toll-free 1-888-313-2665

Visit us on the Internet at www.arcadiapublishing.com.

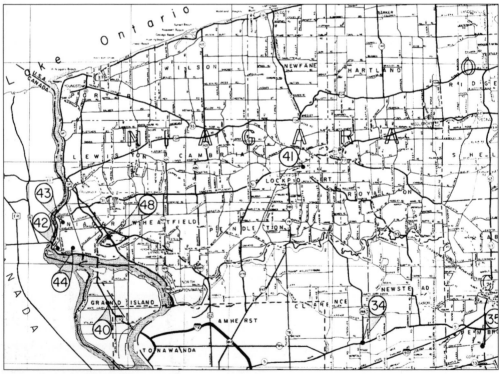

NIAGARA COUNTY. This c. 1950 map of Niagara County was issued for customers of the Manufacturers & Traders Trust Company.

Contents

FOREWORD

Pictures of Lockport a half-century ago frequently draw exceptional interest whether published or shared from home collections at reunions. Those of us who live here now are intrigued to see the folks and fixtures of earlier Lockport. Imagine, then, the fascination with pictures that go back 100 years or more.

Lockport goes back to the beginning—nearly 200 years back. It is a rich treasury of images, illustrations, and stories of a great homeland. Yes, it has the pictures that ignite conversations at reunions, as well as the the classic Lockport frames. It also has a surprising assortment of graphic teasers that will take you back. Added to the narrative are remarkable stories filled with historical detail.

Understandably, you will want to go through the book immediately. However, please consider your first visit inside these pages just a beginning. By all means share *Lockport* at gatherings. You will not need to encourage others to comment on their favorite scenes or to relate their experiences. The discussion will be lively, and questions may come up. Let those point you toward new discoveries and, perhaps, further historical pursuits.

Lockport has a huge history—much more than just a canal town, an industrial center, or a home of highly inventive contributors. Lockport's past, like this guide, is a reminder of everything we should be proud of. Savor the remembering.

—Bob Rooney
Editor, Lockport Home Page
www.Lockport-NY.com

INTRODUCTION

Lockport is the county seat of Niagara County on the Niagara Frontier. For much of its history, Lockport itself has been at the frontier of invention and innovation. Though small, its astonishing concentration of important industries and creative genius still have an impact on our daily lives. Some of the area's innovations are the fire hydrant, automobile radiator, aluminum, first public school system, first commercial telegraph line, first automatic voting machines, and largest wallboard manufacturer. Many Lockport men and women have used their intelligence, power, and wealth to make them the movers and shakers of their day.

Lockport was in the right place at the right time. Because of its location on the Erie Canal, it was crucial to United States expansion from 1817 to 1825. The canal made its incredible journey from the Hudson Valley, along the Mohawk River, climbing 80 feet up a sheer stone escarpment and connecting to the Niagara River into Lake Erie. It was the only possible route through the Appalachians. The canal opened trade from the vast plains of the Midwest to the teeming cities of the Eastern Seaboard, all through Lockport, where a stunning feat of engineering built the flight of five locks up the escarpment.

Before European settlement, the Lockport area was part of the Native American confederation of Five (later six) Nations. It was dense forestland, intersected by trails followed by fur trappers. This land was opened up for settlement by the Treaty of Paris in 1783.

The Holland Land Company bought three million acres of Western New York land in 1791 from Robert Morris, a Philadelphia entrepreneur. It was surveyed and divided up into lots for sale in 1799, when Transit Road was laid out. The road was hand hewn, 800 feet wide, and built through dense forest and treacherous swamp. This cleared track, from Lake Ontario to Pennsylvania, crossed the escarpment at the future site of Lockport. The first European settler was Adam Strouse, who built a log cabin at Cold Springs the same year. Another pioneer, Charles Wilbur, built his first house (later an inn) there in 1805.

Niagara County was established in 1808 and included what is now Erie County until 1821.

Beginning in 1816, a Quaker family called Comstock and others bought land, planted the first orchard (the future Odd Fellows Farm), and built homesteads and the first church, which was a Quaker church. Mills arose along Eighteen Mile Creek and, in 1818, the first settlement on "the Hill" began. The first store opened in 1820 (on the site of 40 Main Street), and the first tavern was built in 1820 (on the site of Scirto's on Main Street).

In 1817, the New York State Legislature passed a bill authorizing construction of the Erie Canal. This was a triumph for Gov. DeWitt Clinton, who had promoted his vision of the canal

connecting the Atlantic Ocean to the Great Lakes. Its construction was the 19th-century equivalent of a moon mission. The canal opened the West for trade and created Lockport, its name, and its wealth. Jared Comstock made a fortune from his escarpment land, bought up by the canal developers. Addison Comstock got a contract for excavating the route. At a community meeting in 1820, citizens voted to name the settlement Lockport over Locksborough in anticipation of the canal's arrival. An army of Irish laborers arrived to build the canal, and many stayed in Lockport and raised families. The 1825 canal opening was celebrated up and down its banks. Rapid development followed. Forest and swampland around Lockport was cleared, and roads were laid out. Lowertown was first developed in 1829. The town of Lockport was incorporated in 1824, carved out of Cambria and Royalton. The village of Lockport was incorporated in 1829.

The canal brought vast ever-growing trade through Lockport. Half a million bushels of wheat had passed through its locks by 1837, and over a million bushels had passed through by 1846. Despite the tolls and costs of freighting bulk goods by canal, it was still only one-tenth of the cost of shipping by road. The real wealth for Lockport was not what came through the locks, but what came down them—the rush of excess water channeled into raceways. Hydroelectric energy was used to power mills, bakeries, and other industries, such as machine-tool manufacturing. Until 1880, Lockport had more generating power than Niagara Falls.

Lockport grew steadily in the years leading up to the Civil War. A downtown around Main Street began to appear, with stores, hotels, and saloons. George Merchant developed Merchants' Gargling Oil, a patent remedy that was one of city's best-known products. Mills thrived. Stone quarrying was prominent. Lockport Glass began making a product that later became famous and highly collectible. In the 1850s, a large influx of Germans moved into Lockport. Sullivan Caverno, lawyer and educator, put forward his concept of a public school system that was the first in United States. Another first was a commercial telegraph line spanning from Lockport to Buffalo in 1845. Further technological innovations came to Lockport: steam trains, steam canal boats, and the inventions of Birdsall Holly, who was a veritable Edison of western New York. While in Lockport, Holly invented the fire hydrant, and district central heating by steam power. He churned out ideas and proposals far ahead of his time and had a vision for the skyscraper half a century before the Chicago School.

So passionate was the desire to stop slavery that Lockport sent a disproportionately large number of men to fight in the Civil War. William H. Bush, proprietor of the Oyster Saloon on Pine Street, is on record as the first volunteer in the country to join the cause. Lockport had been an important staging post of the Underground Railroad. Regiments raised in Lockport included the 2nd Regiment of Mounted Rifles, 129th Regiment Infantry (later 8th Regiment Heavy Artillery), Battery M 1st Regiment Light Artillery, 17th Independent Battery Light Artillery (Orleans Battery), 19th Independent Battery Light Artillery (Stahl's Battery), 22nd Independent Battery Light Artillery (later part of 9th Regiment Heavy Artillery), 25th Independent Battery Light Artillery, and the 151st Regiment Infantry. The total number of dead from these regiments was 1,614. All were from New York, but not all were Lockport men. More soldiers died from disease than from enemy gunfire.

The Civil War ended in April 1865. That same month, Lockport celebrated its achieving of city status. Lockport's industrialization continued, with the Trevor Manufacturing Company, which produced large cutting machinery and became renowned nationwide. Mills and other steam-powered enterprises lined the canal banks. Holly's revolutionary district heating system was laid out. The increased education, wealth, and power of its citizens brought culture to Lockport, exemplified by the Hodge Opera House, completed in 1872. Gas lighting gave way to electricity in the 1880s, and telephones appeared in 1887. By 1895, electric streetcars made their way through the city. Cowles Chemical Company, located on West Jackson Street, produced another first in 1887, with the world's first commercial smelting of aluminum. When Lockport citizens cast their votes in the 1892 elections, they were the first in the world to do so using automatic voting machines.

The 20th century began with the production of Lockport's own automobile, the Covert Motorette, following experiments by Byron Covert with steam automobiles. Industrial expansion continued, as Herbert Harrison invented the honeycomb radiator and founded Harrison Radiator in 1910, and Charles Upson founded the Wallboard Manufacturing Company the same year. Both enterprises went on to become world-famous corporations. From 1908 to 1918, the Erie Barge Canal was completely rebuilt by largely Italian laborers, who stayed in Lockport and raised families. The canal changed its name to the New York State Barge Canal.

Throughout the first half of the 20th century, Lockport was proud of its successful industries and survived the Great Depression with its businesses largely intact.

The two world wars had an impact on Lockport: the conversion of factories to war production ensured its continued wealth; it was still an important mercantile city in the 1940s and 1950s. The decrease of trade on the canal contributed to its decline, but the collapse of the nation's automotive industry in the 1970s crippled it.

An ill-conceived federal program called urban renewal gutted the city center of its handsomest buildings, blighting the downtown area. Businesses relocated as the rural outskirts grew (along Transit Road), and Lockport shrank as families moved out into the golf belt.

The story of Lockport and its canal is not over; indeed, a new chapter is just beginning. Few freight barges now clear its locks, but tourists in increasing numbers are discovering the pleasures of canalboat travel. The canal bank, once grey and industrial, is now green and inviting, with pathways that draw joggers and walkers. Lockport's fascinating heritage is starting to be rediscovered and utilized, with boat trips through the old hydraulic power raceways (the Lockport Cave), a revived trolley, and newly invigorated cultural events and festivals that celebrate the food heritage of the Fruit Belt and the cultural diversity of community. Lockport is still a proud and active city.

ACKNOWLEDGMENTS

This publication would not have been possible without the help of many individuals and institutions, notably Bob Rooney, editor of the Lockport Home Page, the staff of Lockport City Library, the Niagara County Historical Society Museum, and too many Lockport residents to name. Special thanks go to Emma Peca, Ida Marie Scalzo, Sam Marotta, and my husband, Stephen Pewsey, for all his time and encouragement. I also record grateful thanks to Blanche Gregory, Bucknell University, Ashland University, the City University of New York, Columbia University, the Diocese of Buffalo, the Johnson Space Center, Lockport City School District, Maia Image Archive, Tyty Nursery, Union College in Schenectady, the University of Rochester, the U.S. Patent Office, Philip Pewsey for advice on police history, the *Washington Post* for permission to use images reproduced in this publication, and Niagara County Historical Society for permission to use the photograph reproduced on the cover. All other images are from the author's collection.

One
STREETS AND VIEWS

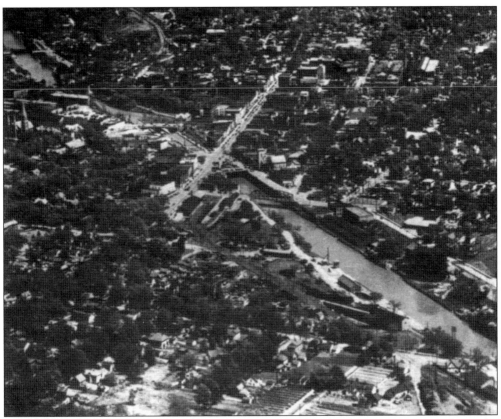

AN AERIAL VIEW. Seen here is Lockport in its 1950s heyday. Main Street runs down the center, crossing the New York State Barge Canal. St. Patrick's Church is prominent on the left.

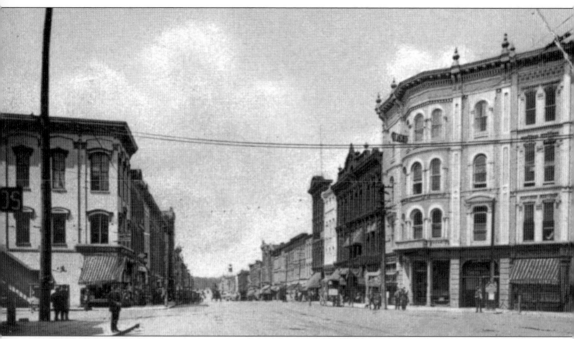

LOOKING DOWN MAIN STREET, C. 1900. The Hodge Opera House stands on the corner of Market Street. The red-striped awning, which was very popular on Main Street from 1850 to 1900, shades the storefront of Staats News. James Staats, who died in 1898, was a notable Lockport publisher who produced some of the its earliest city directories. Locust Street is on the left.

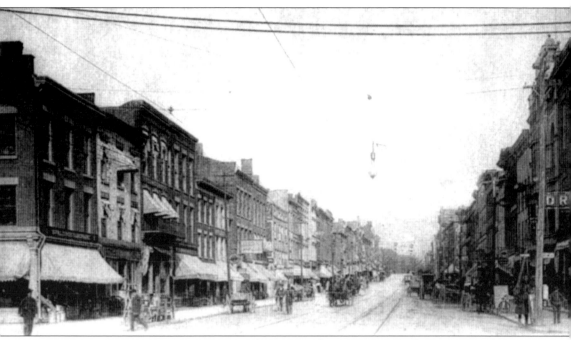

MAIN STREET, LOOKING EAST, 1905. In this view is the same section of Main Street, facing toward East Avenue. Spalding's Electrical Store is on the left. This part of Main Street was first paved in 1856 and, in 1892, was further improved with brick paving.

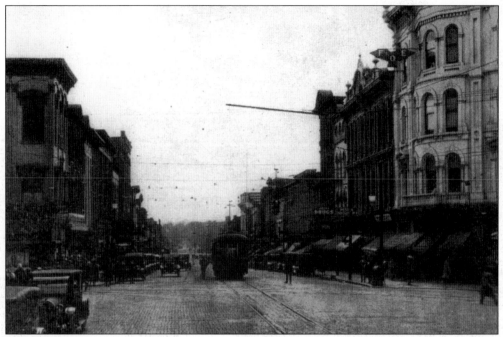

MAIN STREET, FROM LOCUST STREET, C. 1925. Seen is the same view *c.* 1925. A tram car trundles down the street, and automobiles have replaced the horse-drawn transportation of the earlier scene. The Lockport Horse Car Railroad began operating 1876, followed by Lockport Street Railway in 1886. In the earliest years of the 19th century, Main Street was known as the Mountain Road and ran between the road to Lewiston Road at Cold Springs and Upper Mountain Road in Cambria.

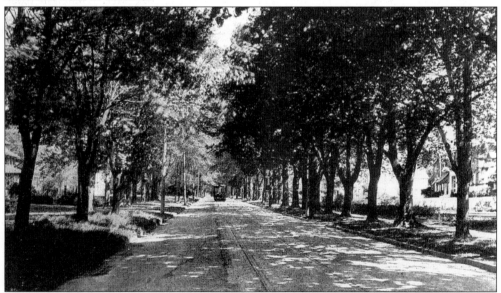

LOCUST STREET, 1925. A tram approaches on this tree-lined street, where many of Lockport's wealthier residents built large impressive houses in the late 19th and early 20th centuries. This area known as "the Hill" is the oldest part of Lockport. The very first dwellings, log cabins, were built here in 1818.

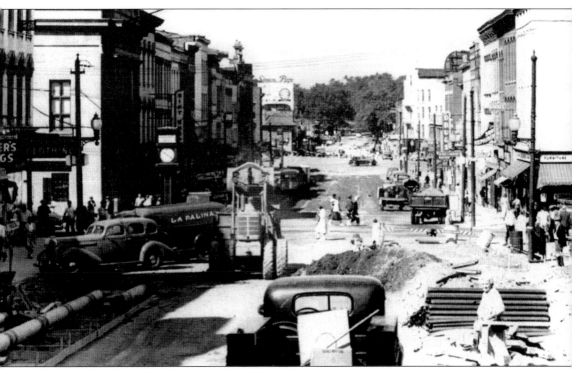

THE JUNCTION OF MAIN AND PINE STREETS. In this bustling street scene, pipes are being laid at the junction of Pine and Lock Streets. Singer's Drugs is on the left, fondly recalled by older residents for its 4¢ candy bars. Niagara County National Bank is across Pine Street. On the right side of Main Street is the huge arched window of the Manufacturers & Traders Bank, on the corner of Lock Street. Pie's Furniture is on the other side of Lock Street. This entire block was demolished as part of Lockport's urban renewal.

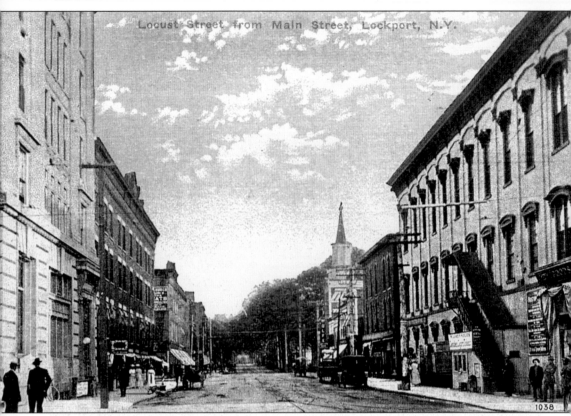

LOCUST STREET, FROM MAIN STREET. This road was originally known as East Third Street. The Farmers & Mechanics Bank building is on the left. Jay's Drug Store later occupied the prominent corner position to the right of the junction.

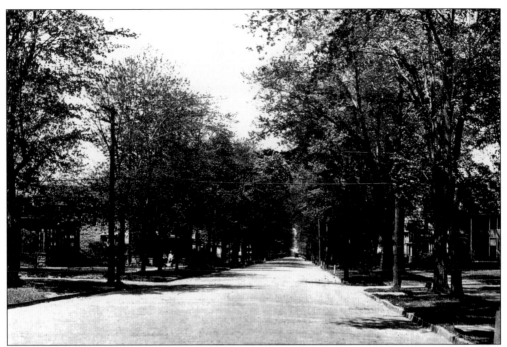

NIAGARA STREET, LOOKING WEST, 1925. The county courthouse and jail opened on this street in 1825, followed by a poorhouse and farm in 1828 at the western (town of Lockport) end of the street and, later, the county clerk's building. The street is now also home to Niagara County Historical Museum, located at 215 Niagara Street.

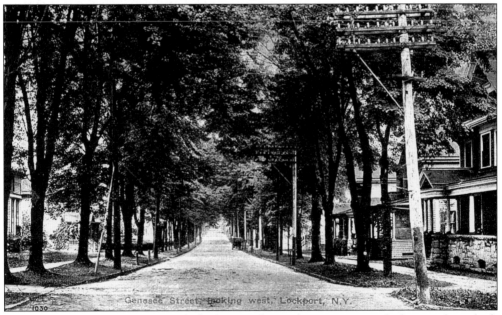

GENESEE STREET. This surprisingly leafy view shows the prominent telephone poles, which were a recent technological revolution when this postcard was issued; the first telephones were installed in Lockport in 1885. Genesee is a common place-name in western New York. It comes from the Iroquois language and means "beautiful valley."

17

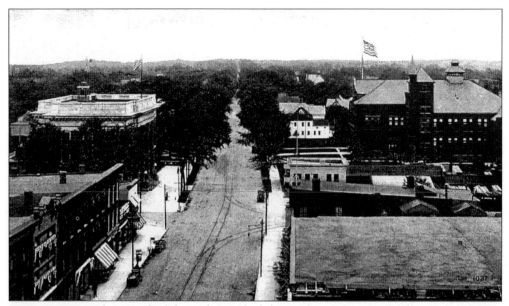

EAST AVENUE. Photographed from the roof of the Lockport Savings Bank is East Avenue. Across the street from the federal building is Union High School. Both buildings proudly fly the Stars and Stripes.

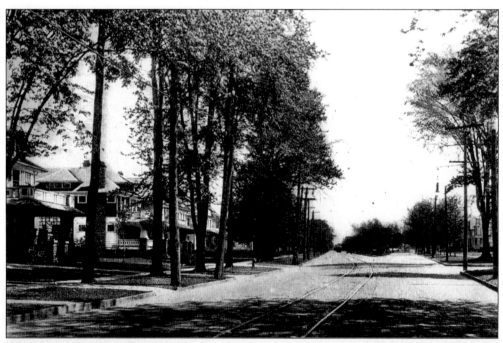

EAST AVENUE, 1925. The street divides ahead around East Avenue Park, which was renamed Veterans Memorial Park in 1985. East Avenue, on the left, follows the old Mohawk trail that crossed Western New York. LeVan Avenue, on the right, is named after Daniel LeVan, who moved from Pennsylvania to Lockport in the 1820s or 1830s.

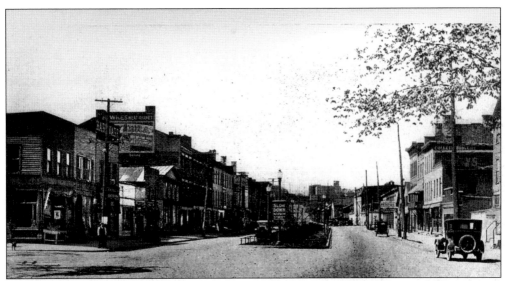

MARKET STREET, 1925. This street was built as a result of an 1826 New York State decree to construct a canal-side road between Lockport and Rochester. This once thriving part of Lockport was known as Lowertown or Happy Valley. Busy shops flanked both sides of the street; the canal-side buildings have long since been demolished. Early wealthy settlers built grand homes along Market Street, but the city's elite later relocated up the hill in areas like Locust Street. Lowertown became the home to newcomers: the Irish and Italians. It is now on the National Register of Historic Places.

RIDGE ROAD. This is another road that began life as a Native American trail. It runs from Warren's Corners to Niagara Falls and follows an ancient shoreline of Lake Ontario, which is marked by a clearly defined ridge below the escarpment.

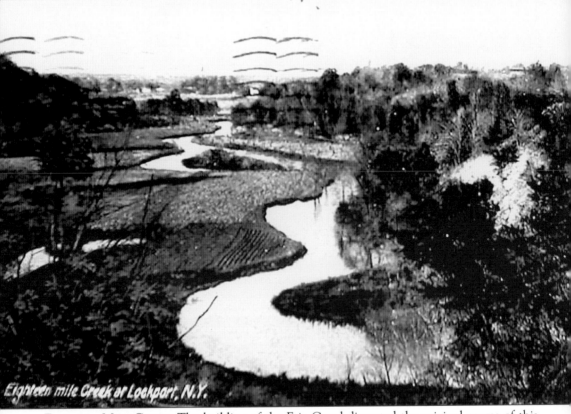

Eighteen mile Creek or Lockport, N.Y.

EIGHTEEN MILE CREEK. The building of the Erie Canal disrupted the original course of this river, which ran through the center of Lockport. Much of it is now in culverts beneath the city streets, although in the early days of Lockport, the water flow powered several mills.

Two

SERVICES

THE LOCKPORT CITY SEAL.
This seal, with its flight of
locks up the Niagara
escarpment, is the perfect
emblem for the city of
Lockport. The township was
created on February 2, 1824, and
was incorporated as the city of
Lockport on April 11, 1865. One
month later, on May 9, 1865, it held its
first election. Benjamin Carpenter became
the first mayor.

ABSTRACT FROM CENSUS REPORT

OF 1865.

NIAGARA COUNTY.

POPULATION.

TOWNS.	Population in 1865.	Changes since 1855.		VOTERS, 1865.			Aliens, 1865.	Colored persons not taxed, 1865.	Number, deducting aliens and colored persons, not taxed.
		Increase.	Decrease.	Native.	Naturalized.	Total.			
Cambria,	2,115	101	411	70	481	174	2	1,939
Hartland,	3,445	412	656	138	794	281	1	3,163
Lewiston,	2,998	262	365	172	537	472	27	2,499
Lockport,	13,937	551	1,892	954	2,846	1,512	164	12,261
Newfane,	3,246	82	667	115	782	249	8	2,989
Niagara,	6,186	729	453	535	988	1,229	114	4,843
Pendleton,	1,731	95	209	159	368	156	1,575
Porter,	2,366	277	379	117	496	271	3	2,092
Royalton,	4,691	239	829	258	1,087	469	2	4,220
Somerset,	1,787	136	381	62	443	141	...	1,646
Wheatfield,	3,517	365	219	450	669	493	2	3,022
Wilson,	3,264	28	629	102	731	263	8	2,993
Tuscarora Ind. Res.,	372	56
Total,	49,655	1,057	7,090	3,132	10,222	5,710	331	43,242

AGRICULTURAL, ETC.

TOWNS.	Winter Wheat—bushels harvested 1864	Oats, bushels harvested 1864.	Indian Corn, bushels harvested 1864.	Potatoes, bushels harvested 1864.	Tobacco, pounds harvested 1864.	Hops, pounds harvested 1864.	Apples, bushels harvested 1864.	Milch Cows, number of, 1865.	Butter, pounds made 1864.	Horses, two years old and over, 1865	Sheep, number shorn 1865.
Cambria	25877	31872	36064	20340	3110		36121	867	84099	879	8177
Hartland	12480	53548	62046	37090	17650		28015	1088	100772	1107	10558
Lewiston	12566	23629	29120	15633	9756		14130	838	64820	925	7037
Lockport	24884	29280	44275	26107	12000	3100	36330	1438	96570	1318	8976
Newfane	10051	60075	81977	45090	19800	7493	35990	1072	95243	1097	12295
Niagara	5605	17054	8437	10337			6126	511	32051	581	1182
Pendleton	13294	22324	9999	8993		4800	12666	576	51660	463	3473
Porter	5741	26888	36254	15731	30740		18216	697	80396	752	10486
Royalton	37427	60215	49688	26129	3905		76986	2236	135245	1761	19195
Somerset	7031	52374	51240	24417	12800		35287	654	83373	709	4700
Wheatfield	15725	36120	14028	22455	1800	122	5788	785	49510	620	2735
Wilson	14030	53316	67523	29969	14950		30036	1098	92547	973	17017
Total	184711	456695	490651	282291	88211	15515	335691	11860	966286	11224	105831

THE 1865 CENSUS. This table is full of interesting statistics. Lockport had the largest number of aliens in the county, mostly newly arrived Irish. Lockport had grown faster than any other town and was the largest producer of apples in the county.

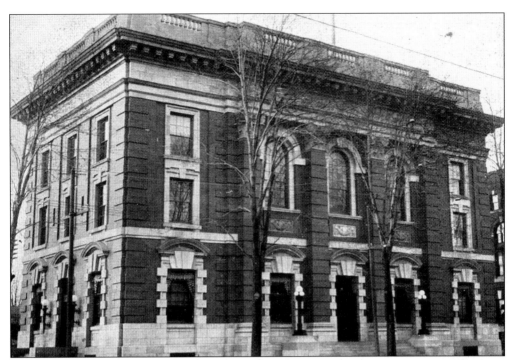

THE FEDERAL BUILDING. The message on this postcard reads "pretty new building." This handsome, solid red-brick building, completed in 1903, was designed in the Beaux-Arts style by James Knox Taylor. When it opened, it housed the post office and courtrooms.

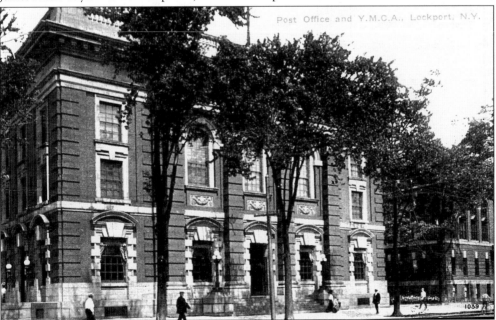

THE POST OFFICE AND YMCA. The post office was housed in the Hodge Opera building before it moved into this edifice, which is now listed in the National Register of Historic Places. The post office has moved across the street into a new building on the site of the Elks office, reputedly standing over the original Lockport Cave (after which nearby Cave Street is named).

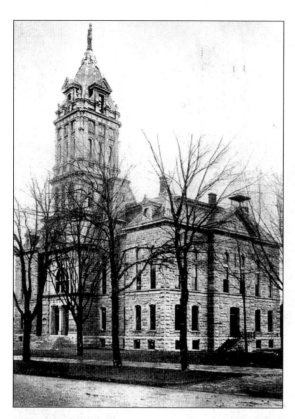

THE COUNTY COURTHOUSE. Before this structure was built in 1887, the first county court (built in 1825) had been on Niagara Street. The first courthouse later became a female prison. The current building faces Hawley Street, which longtime residents may remember as the scene of anxious moments before taking the driving test.

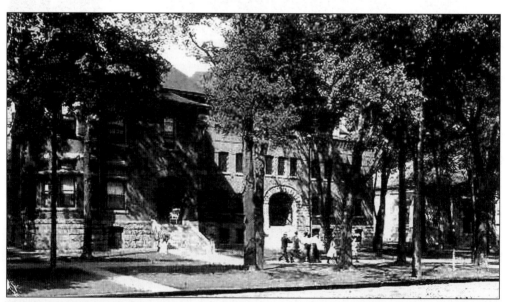

THE COUNTY CLERK'S OFFICE AND THE JAIL, NIAGARA STREET, 1907. Lockport's jailhouse, in its need to expand, has moved several times. The third jail, shown here, was built between 1892 and 1893 of red brick. In recent times, the county clerk's office has been used as a tourist information office.

THE COUNTY CLERK'S OFFICE AND THE JAIL. This eastern view of the jail (left) also shows a long expanse of unbroken sidewalk. The jail stood on the site of the original 1825 jail, which had only four cells. In 1961, this sturdy three-story building was torn down and replaced with a parking lot. The fourth and present jail (built from 1959 to 1961) is located on the western end of Niagara Street, opposite the site of the former poorhouse.

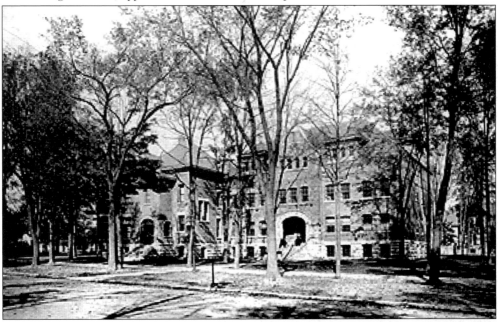

THE COUNTY JAIL. This jail was the scene of Niagara County's only execution. David Douglass was convicted of murder in 1842. He was hanged, and his body was buried in Cold Springs Cemetery. A few days later, the body was missing. A local doctor, in need of a cadaver, had snatched it for medical research. In 1904, a jail break occurred and several prisoners escaped across the Canadian border. They were later recaptured in St. Catherines, Ontario.

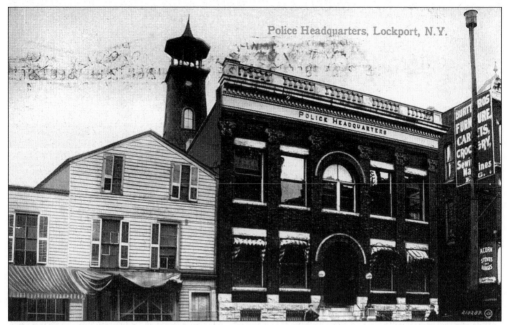

POLICE HEADQUARTERS, C. 1910. Built on Pine Street in 1847 as a carriage shop, the large building (center) was later used by the city police, who formed in 1867. Center Alley, on the right of the station (between the two brick buildings), is now Heritage Court. The former headquarters was demolished as part of urban renewal. The police station is now in Locks Plaza on Main Street.

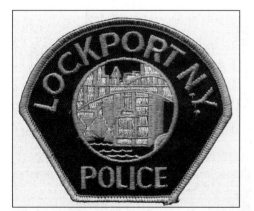
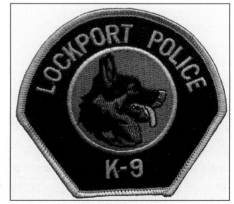

POLICE PATCHES. The city police emblem (left), similar to the city seal, shows the locks and the Erie Canal. The city police canine section has its own distinctive patch (right).

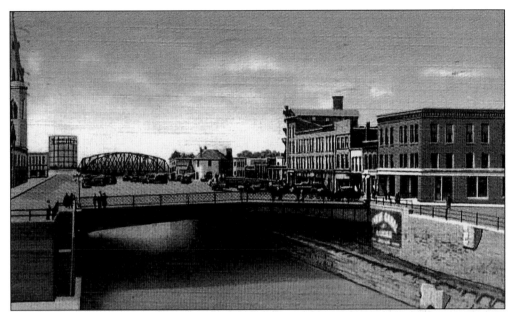

THE FIRE DEPARTMENT. The former headquarters of the fire department was located on the north side of the Main Street on the Big Bridge. Locks Plaza Hotel is to the left. Lockport's first fire company, Protection Fire Company, was organized in 1824. The company bought its first engine 10 years later. Before that, bucket brigades were used. The city fire department was created in 1865.

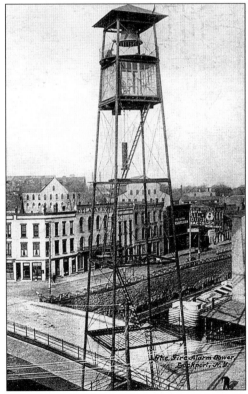

THE FIRE ALARM TOWER. There was an ever-present fear and danger of fire in the early days of city life, when many buildings were wooden. This tower was strategically placed on Main Street in 1889, beside the Pine Street Bridge. It was later moved to Outwater Park. In 1990, the bell was returned to its historic downtown location and incorporated into the Fire Fighters Memorial outside the municipal building.

CITY HOSPITAL. Lockport philanthropist and leading businessman Thomas Flagler built Flagler Hospital in 1888. The town of Lockport's hospital opened on Canal Street in 1837. Shown is City Hospital, which opened in 1908 on East Avenue.

CITY HOSPITAL, A LATER VIEW. In this later view, City Hospital appears more than double its original size. Lockport's philanthropist John Hodge, provided much of the necessary funding for its expansion.

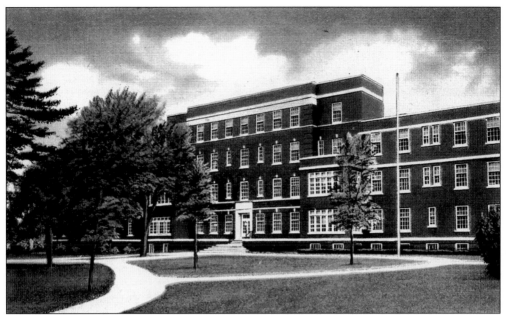

LOCKPORT MEMORIAL HOSPITAL. Renamed Lockport Memorial Hospital, this modern building replaced the former City Hospital on the same site. William Rand Kenan built the adjacent nurses home, known as the Kenan James Building, to the right of the hospital.

COUNTY POOR HOUSE STATISTICS.

The number of inmates of the Poor House October 1, 1867, was 140
Number admitted during the year .. 231
Born during the year .. 4
Whole number discharged ... 242
Number remaining Sept. 30, 1868 ... 133

The causes of pauperism are reported as follows:

Sickness .. 61
Destitution ... 52
Insanity .. 7
Intemperance .. 54
Orphanage ... 27
Cripples .. 12
Blind ... 6
Old age ... 12
Born in Poor House .. 4
The average number of paupers in the Poor House for the year ending September, 30, 1868 .. 192
Average expense per week each ... $1.35

THE COUNTY POOR HOUSE. Lockport took responsibility for the county's poor in 1829. The poorhouse, a farm of 120 acres, was located west of the city on Niagara Street extension, across from what is now the county jail.

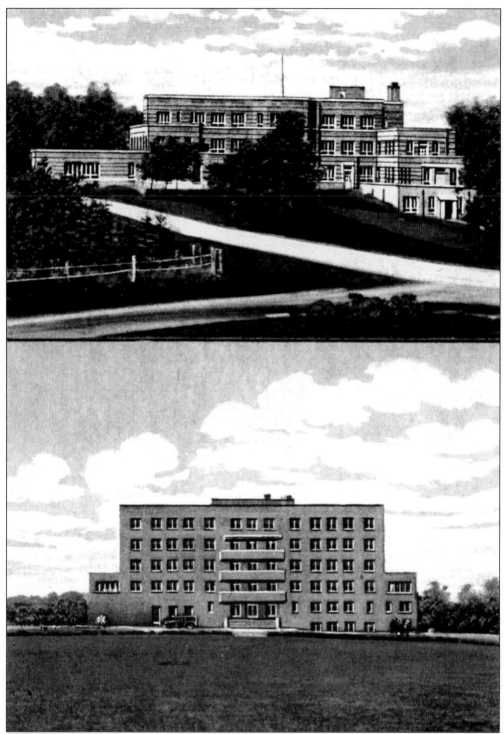

The Niagara Sanatorium. The county tuberculosis hospital, known as the Shaw Building, was built on Mountain View Road in 1918. It is now a long-term care home and has been renamed the Mount View Health Facility.

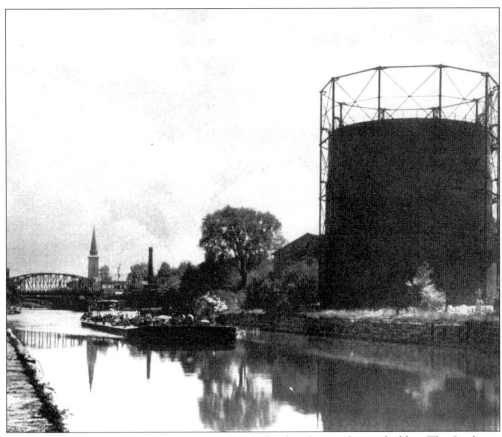

A GASHOLDER. Another prominent canal-side landmark was this gasholder. The Lockport Gasworks was founded in 1851 with Thomas Flagler as its first director and president. Lockport residents were dazzled on New Year's Eve 1851, when gas streetlights blazed along Main Street for the first time. The New York State Electric & Gas (NYSEG) service center is located on Lincoln Avenue.

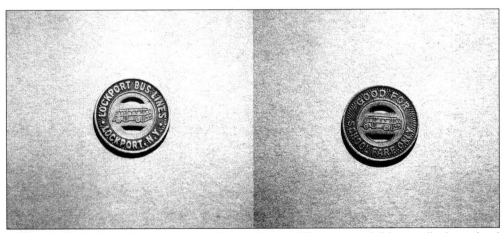

SCHOOL BUS TOKENS. Rain, shine, or through heavy falling snow, children walked to school each day in large, neighborhood groups. Buses were provided for those who lived at a distance.

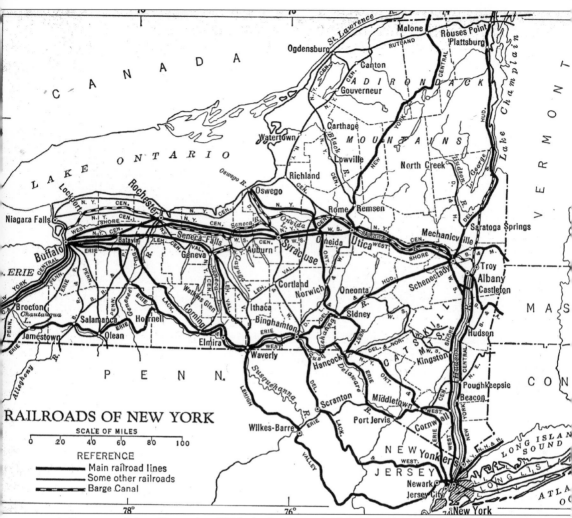

RAILROADS OF NEW YORK

A RAILROAD MAP. Opened in 1836, the Lockport & Niagara Falls Railroad was the area's first. Horse-drawn until 1837, it was nicknamed "the Strap Railroad." It was bought out by the Rochester, Lockport & Niagara Falls Railroad (later the New York Central Railroad) in 1850. A new line of tracks was laid through Upper Town and opened in 1852. More lines followed: the Buffalo & Lockport Railway opened in 1879 and a line to Olcott in 1900 by the International Traction Company.

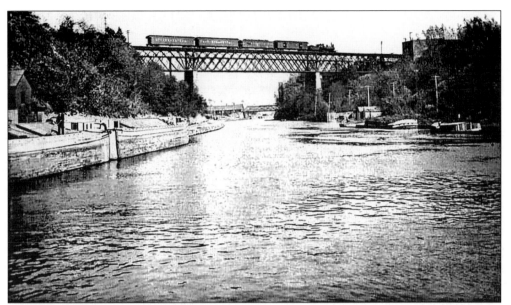

The Upside-Down Bridge. The unusual appearance of this bridge, with its trusses on the underside, makes this one of Lockport's best-known and most-photographed landmarks.

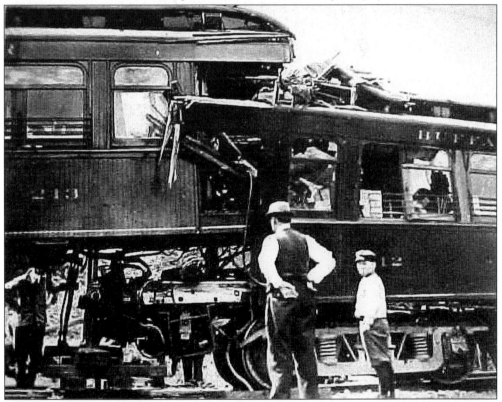

A Train Crash on the Buffalo & Lockport Railroad. In the days before instantaneous satellite news, accidents were photographed and issued as souvenir postcards. This early railroad mishap occurred sometime before World War I.

UNION STATION. Numerous plans to restore the station to its original handsome state have fallen through. It was a restaurant for a while in the early 1970s, but burned down in 1978. Built in 1888, it closed as a passenger terminal in 1957. In 2002, the Niagara & Western New York Railroad Company briefly revived passenger excursions between Lockport, Medina, and Brockport.

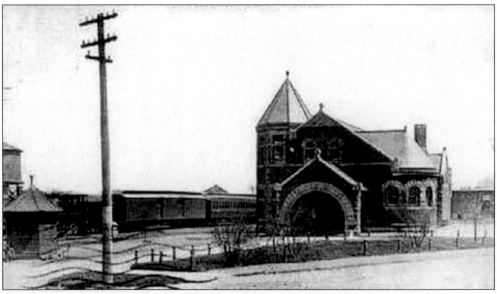

UNION STATION, IN ITS HEYDAY. This late-19th-century photograph of Union Station shows the harmony of the building's original appearance.

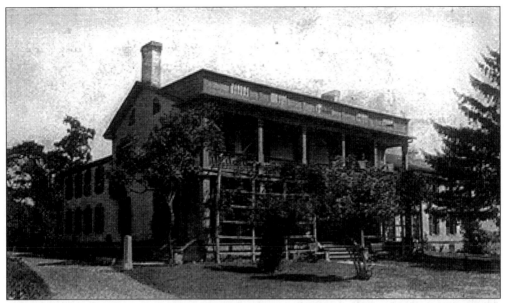

THE ORIGINAL INDEPENDENT ORDER OF ODD FELLOWS HOME. This modest house was built on the old Niagara Road. The Odd Fellows began life as a mutual benefit society, founded in England c. 1748. It arrived in America in 1806 and became autonomous from the English version when the Independent Order of Odd Fellows was founded in Baltimore in 1819.

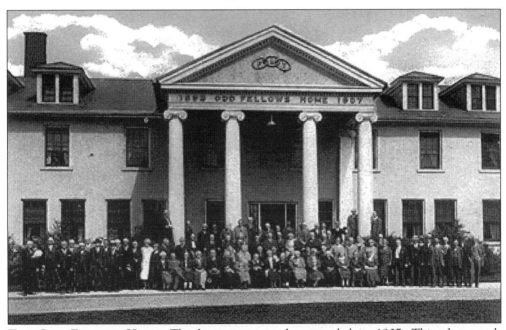

THE ODD FELLOWS HOME. The home was greatly expanded in 1907. This photograph celebrates its opening. The Odd Fellows were the first fraternity that included both men and women. The women's group, the Rebekah Degree, was established in 1851.

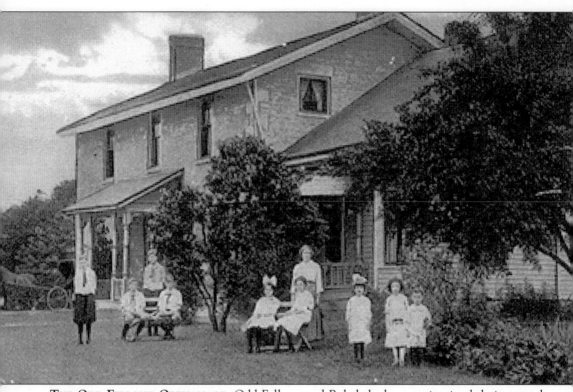

THE ODD FELLOWS ORPHANAGE. Odd Fellows and Rebekahs have maintained their mutual benefit origins by setting up a national network of homes for senior citizens and the orphaned children of its members. The Lockport orphanage is shown here.

Three
INDUSTRIES AND SHOPS

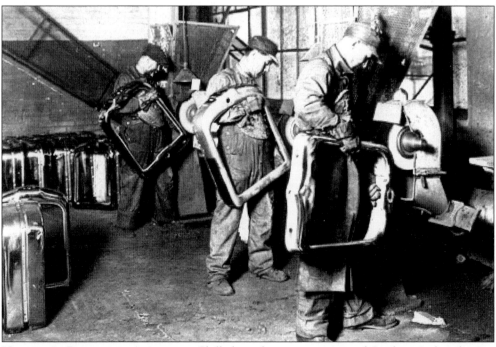

HARRISON RADIATOR ASSEMBLY. Skilled workers create one of Lockport's best-known worldwide exports.

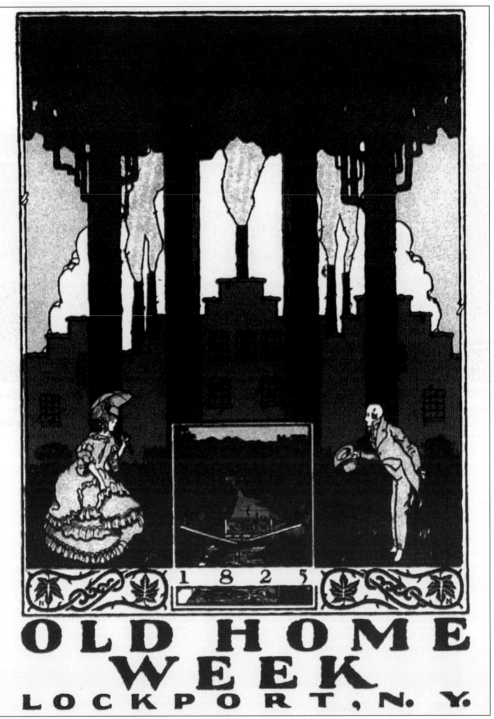

An Old Home Week Brochure Cover. This Art Deco illustration is from the cover of the brochure for Old Home Week 1925, celebrating the 100th anniversary of the Erie Canal. The illustration shows how Lockport viewed itself as a powerful combination of heavy industry, heritage, and elegance.

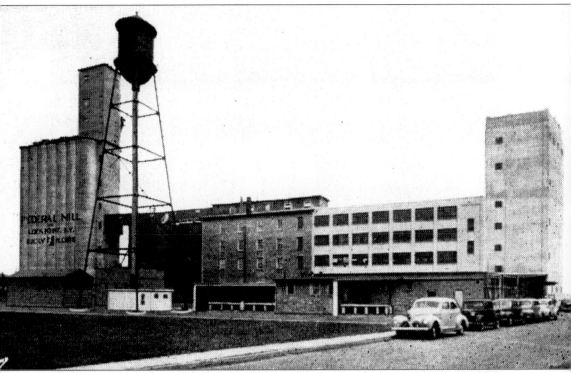

THE FEDERAL MILL. Power drawn from the Erie Canal led to the establishment of the largest concentration of mills in western New York. As early as 1869, more than 2,000 barrels of wheat were being ground daily, using the force of water falling at no less than 32,000 cubic feet per minute.

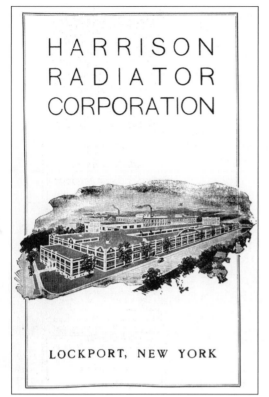

HARRISON RADIATOR'S MAIN PLANT. Founded in 1910 on Richmond Avenue by Herbert Harrison, inventor of the honeycomb automobile radiator, this famous Lockport company's first home was the former assembly plant of the Covert Motor Vehicle Company. This photograph shows the main plant on Walnut Street as it was in the 1920s.

HARRISON RADIATOR. This view shows the juxtaposition of the original Richmond Avenue site of 1910, the Walnut Street main plant, and the "new" 1948 view of the west plant, between West Avenue and Saunders Settlement Road. The company has been Lockport's single most important employer. It was the financial barometer of Lockport through years of prosperity and also during times of massive layoffs. The annual company picnic at Olcott Beach was an important date in Lockport's social calendar for decades.

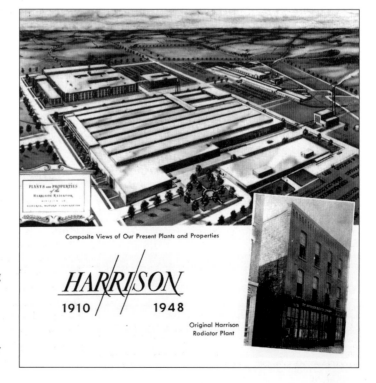

40

UPSON BOARD. Another industry fuelled by hydroelectric power from the canal was timber processing. Sawmills and paper mills lined the canal, and Upson Board was the largest of these industries. Founded in 1910, it was the world's largest wallboard manufacturer until the Depression. Then, it developed the technology to produce affordable jigsaw puzzles under the name Tuco. The Upson family lived on Washburn Street. The Charles Upson School was named after its founder. Niagara Fiberboard, located along the canal on Van Buren Street, still produces wallboard and hosts the traditional Christmas party for on Upson board retirees.

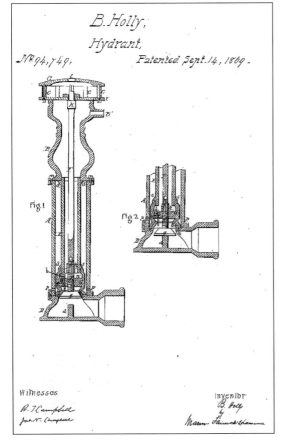

B. Holly,

Hydrant,

Nº 94,749, Patented Sept. 14, 1869.

Fig 1

Fig 2

Witnesses:
R. T. Campbell
Jno. N. Campbell

Inventor
B. Holly
by
Mann. Hannock & Hammer

HOLLY MANUFACTURING COMPANY. Inventor Birdsall Holly began manufacturing sewing machines, pumps, and hydraulic machinery in 1864. His company was enticed to develop in Lockport after local businessmen made the powerful water raceway created by the locks available for industry. Holly's dual interest in pumps and firefighting developed into the first system in the country that offered a steady, reliable flow of water for fighting fires. This system combined a pumping station with underground pipes and fire hydrants.

NIAGARA HOTEL. This hotel is one of Lockport's longest standing businesses. According to the Niagara Directory of 1869, "His [the proprietor's] table is always supplied with the delicacies as well as the substantials of the season."

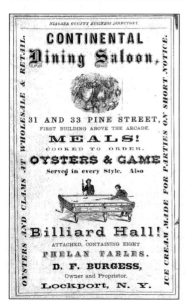

CONTINENTAL DINING SALOON, 1869. The needs of the inner man were satisfied at this establishment, where oysters and ice cream could be enjoyed, followed by a game of billiards.

LOCKPORT NEWSPAPERS. The first newspaper, the *Lockport Observatory*, played a crucial role in ensuring that Lockport gained county seat status in 1822. The *Lockport Daily Union* (left), founded in 1847, amalgamated with the *Lockport Sun* in 1895. *The Lockport Journal & Courier* grew to prominence in 1851 under the formidable proprietorship and editorship of M.C. Richardson. The paper later amalgamated with the *Lockport Daily Journal*, creating the *Union Sun & Journal*, which still exists today.

D.F. BISHOP, M.D., OF LOCKPORT. An astonishing claim is made by a Lockport doctor in this mid-19th-century advertisement.

SMALL ADVERTISEMENTS. These delightful small advertisements from Lockport's past date from soon after Lockport gained city status. Perhaps they reflect its grander social aspirations.

FASHIONS, FADS, AND LUXURIES. These advertisements provide an instant picture of fashions, fads, and luxuries of post Civil War–era Lockport. Lockport Marble was long considered the finest in the country and was sought after for ornamenting public buildings across the country.

LARGE STORES. Jerome B. and John L. Davison had a wide range of businesses in 19th-century Lockport, including jewelry, woolens, and "gent's furnishing goods." The family later gave Davison Road its name. Earlier Shaffer, Bouck & Company, Bouck and Sanders was Lockport's largest dry goods store until eclipsed by Josiah Breyfogle, whose large store on the corner of Locust and Main Streets thrived for many years.

SPALDING CLOTHES. S.Z. Spalding was the city's leading boys' clothier. She was the wife of prominent Lockport citizen Lyman Spalding. The success of her store later allowed her to move her establishment from Pine Street to a larger emporium on Main Street.

45

MONTGOMERY WARD

130 MAIN STREET, LOCKPORT, N. Y.

PHONE HF 3-6767

FOR
QUALITY BRANDS
PLUS
LOW PRICES

MONTGOMERY WARD. "Monkey Wards," also on Main Street, never enjoyed the status of Williams Brothers, but it provided a variety of good-quality merchandise, including hardware, all under one roof.

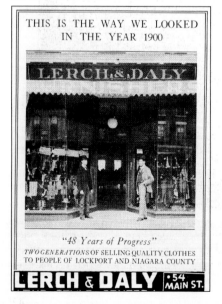

THIS IS THE WAY WE LOOKED IN THE YEAR 1900

"48 Years of Progress"
TWO GENERATIONS OF SELLING QUALITY CLOTHES
TO PEOPLE OF LOCKPORT AND NIAGARA COUNTY

LERCH & DALY · 54 MAIN ST.

LERCH & DALY. Begun *c.* 1900, Lerch & Daly quality men's wear is surpassed only by its staying power on Main Street. By 2003, it was the oldest surviving clothing store in downtown Lockport, but like many other stores, declining business forced it to close in June of that same year.

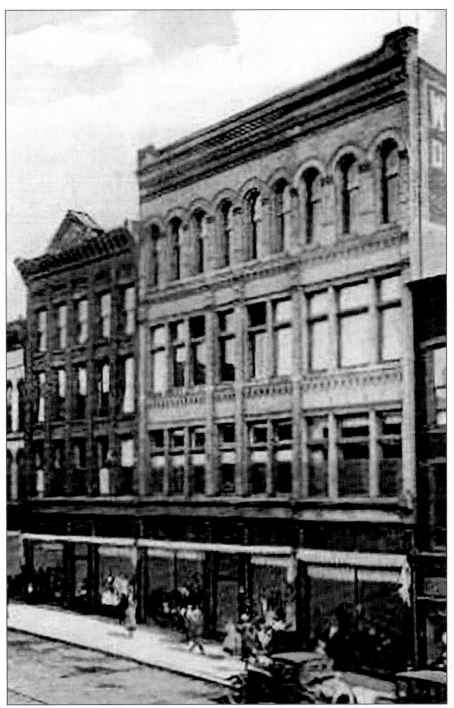

WILLIAMS BROTHERS. Williams Brothers was the place to buy quality ladies' clothes. Longtime residents will remember spending hours lined up at the store's excellent gift-wrapping service during the holiday season. Williams Brothers was one of Lockport's longest-surviving stores, founded in the mid-19th century and remaining as a Main Street landmark until it closed in the wake of urban renewal.

CHARLES GURSLING & COMPANY. Small traders such as Charles Gursling & Company—coffee, tea, and spice dealers—flourished during Lockport's late-19th-century boom, bringing touches of luxury to home life.

THE COMPTON MCMASTER PIANO STORE. In the 19th and early 20th centuries, Lockport boasted several stores selling pianos. The piano had become an indispensable piece of furniture in every polite drawing room. Compton McMaster advertised its wares with numerous series of humorous trade cards.

O'KEEFE'S BOOK STORE. This delightful, snowy scene is an example of the trade card style available in the late 19th century.

KENNEY'S SHOE STORE. J.F. Kenney & Company, at 67 Main Street, supplied shoes for generations of Lockport schoolchildren.

J.F. KENNEY & COMPANY. The individual attention given to customers at Kenney's has long since disappeared, along with much else on Lockport's Main Street.

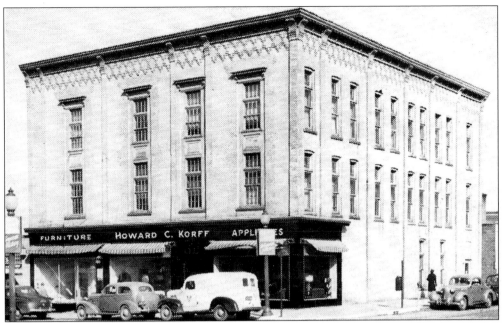

HOWARD C. KORFF FURNITURE. Also standing on the corner of Pine and Walnut Streets was the Korff building, where quality furniture was sold.

"AS I STAND HERE TODAY"

Imagine your feeling of mental contentment and pride — the thought of being well groomed, as you stand on the stage before your classmates, devoted parents and other friends in that never-to-be-forgotten Graduation Day.

All this can be yours— mental contentment, neat appearance, happiness and all if you wear a

BREES MADE SUIT

Blue Suits in Single or Double Breasted, Plain and Fancy Models $27.50 to $42.50

White Flannel and Serge Trousers, $4 to $8

Graduation Shirts, Underwear, Hosiery, Neckwear

E. W. BREES & SON

92 Main Bell 139-W

"LOCKPORT'S LEADING CLOTHIERS"

E.W. BREES & SON CLOTHIERS. Located at 92 Main Street, Brees, "Lockport's leading clothiers," was one of a number of competing clothing stores in the downtown area.

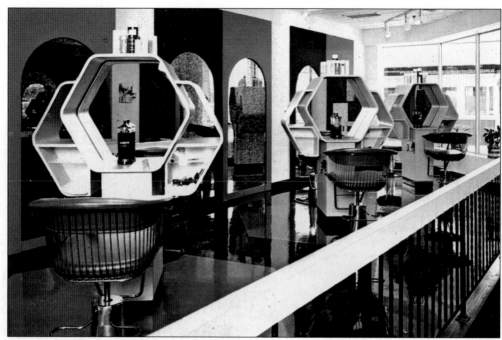

COMMAND PERFORMANCE, LOCKPORT MALL. From the 1950s on, plazas, which were later followed by malls, along Transit Road drew trade away from the downtown area. This *c.* 1970 view shows a then up-to-date hairdresser's shop—an early tenant of Lockport Mall.

SMALL STORE ADVERTISEMENTS. These advertisements demonstrate the diversity of trade and entertainment during the interwar years. Corson Manufacturing Company, papermakers and printers of Michigan Street, went bankrupt in 2000. In the 1940s, the Corson family owned the *Union Sun & Journal* and the local radio station WUSJ.

52

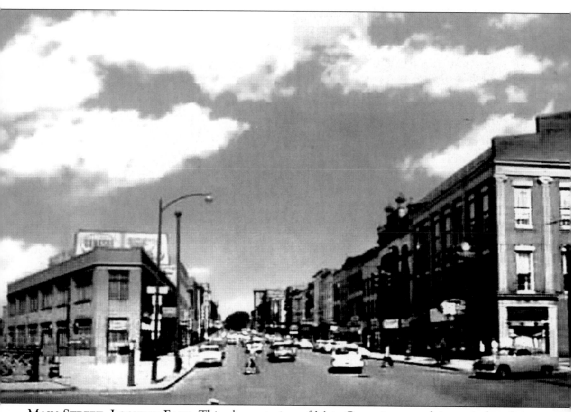

MAIN STREET, LOOKING EAST. This pleasant view of Main Street is a nostalgic reminder of a time before urban renewal, when people went shopping downtown and found a place to park.

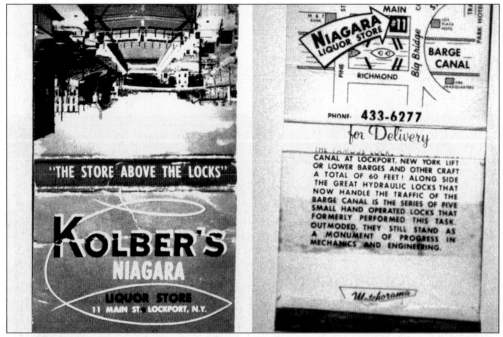

KOLBER'S LIQUOR STORE. Matchbooks were the 20th century version of the elaborate trade cards seen earlier, as this example advertising Kolber's Liquor Store shows. The store stood on Main Street near the Big Bridge.

ADVERTISEMENTS OF THE DAY. George Merchant came to Lockport in 1831, bought out a drugstore and its contents, and developed what turned out to be the most popular, widely distributed cough and cold remedy of the 1800s: Merchants Gargling Oil (left). This potion secured a vast fortune for Merchant and his successor, John Hodge, who bought out the company. Advertising in 1922 (right) was the Hi-Art Theatre, on West Avenue, one of no less than five movie theaters at the time, including the Palace, the Rialto, the Star, and the Temple.

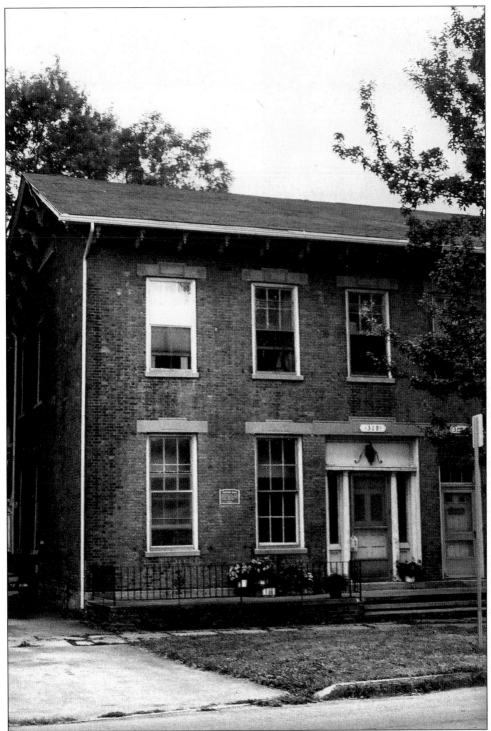

THE FIRST BANK IN NIAGARA COUNTY. The first bank in Niagara County was started in 1829 on Market Street near Chapel Street. It was called the Canal Bank and later the Lockport Bank. It was closed briefly between 1837 and 1838 for fraudulent accounting practices.

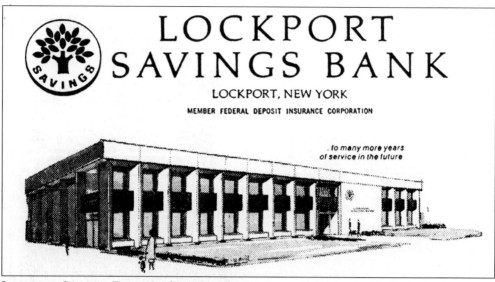

LOCKPORT SAVINGS BANK

LOCKPORT, NEW YORK

MEMBER FEDERAL DEPOSIT INSURANCE CORPORATION

. to many more years of service in the future

LOCKPORT SAVINGS BANK. In the 1960s, the Farmers and Mechanics Bank changed its name to Lockport Savings Bank. This modern design symbolized an unfulfilled promise of development for the downtown area, but the East Avenue building has since been superseded by a newer, brasher headquarters on Transit, more branches throughout the county, and also by a new name: First Niagara Bank. Fortunately, the rotating time and temperature board continues to provide this vital information to Lockportians.

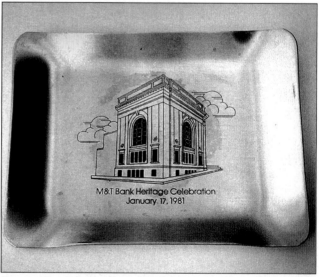

BANK SOUVENIRS. The Lockport Savings Bank Dime Kitty (left) is a charming souvenir from the 1960s that shows how banks and parents alike tried to get children to save money. The patience required to fill this little card with $3 worth of dimes is hard to imagine in the debt-ridden society of the early 21st century. "It is not what you earn—but what you save that counts," was the printed encouragement. The great arched windows of the Manufacturers & Traders Bank are shown in a souvenir ashtray (right) that was issued in the final years of the bank's residence at its prominent downtown lot. Opened in 1920, this landmark building , with its Art Deco origins, is now the headquarters of the Ulrich Development Company.

56

THE FARMERS AND MECHANICS SAVINGS BANK. The Farmers & Mechanics Savings Bank was founded in 1870 on Main Street at the corner of Locust Street. This striking new headquarters was built in 1905 and stood on the site of the American Hotel, one of Lockport's earliest hostelries. In the 1970s, it housed a popular basement bar. The building was later renamed Regency Tower and made available for office rental. Currently, it stands empty.

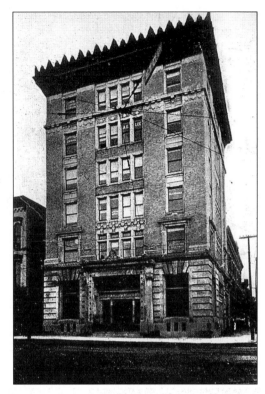

A FARMERS AND MECHANICS SAVINGS BANKBOOK. Seen here is a remnant of a bygone age.

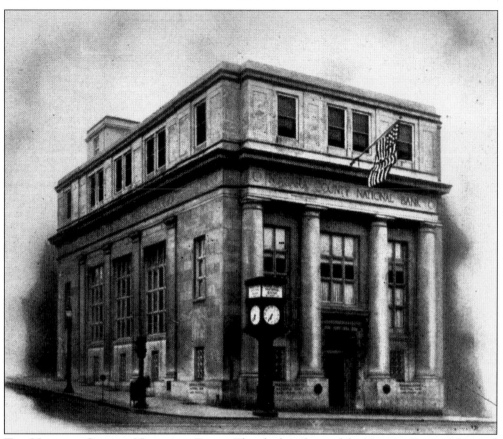

THE NIAGARA COUNTY NATIONAL BANK. The clock in front of the Niagara County National Bank, at the corner of Main and Pine Streets, is another Lockport landmark. The bank has long disappeared, but the building has housed the Corporate Training Center of Niagara County Community College (NCCC) since 1995.

A NIAGARA COUNTY NATIONAL BANK & TRUST COMPANY BANKBOOK. This bank book is another reminder of an older and more personal banking era.

Four
AGRICULTURE

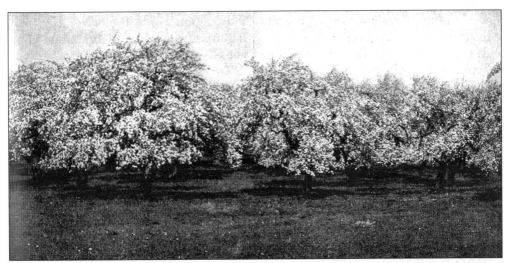

A NIAGARA COUNTY APPLE ORCHARD. Before the current trend of importing all manner of fruit during all seasons, the year was marked by fruit crops. Lockport, at the heart of the fruit belt of western New York, produced raspberries and strawberries in the early summer; cherries, blueberries, peaches, and pears in the later summer; and apples in the fall. Many homes had fruit trees in their backyards, and children knew the location of every cherry tree in the neighborhood.

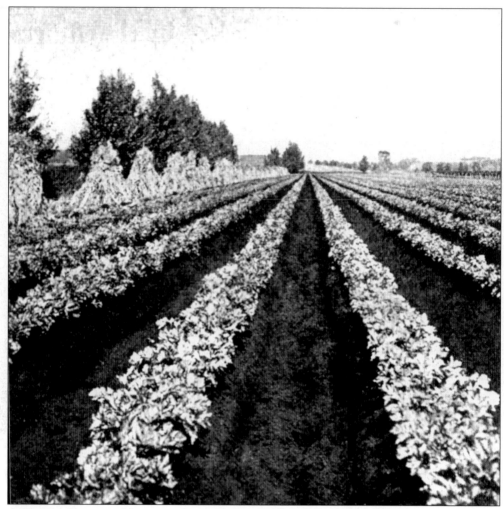

A Celery Field in Niagara County. Essentially an agricultural area, Lockport farmers produced an abundant variety of crops, including tomatoes, corn, eggplant, zucchini, beans, lettuce, cucumbers, and celery.

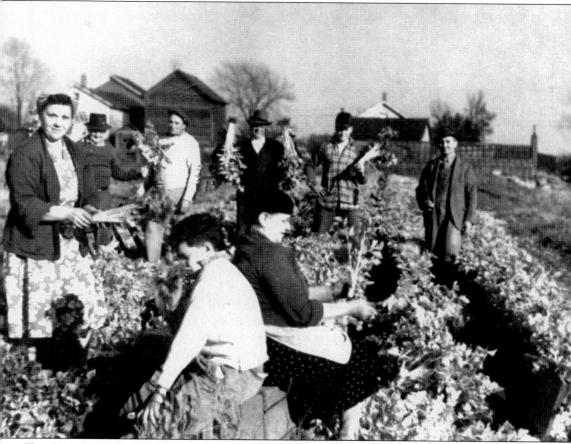

THE MAROTTA FAMILY FARM. Niagara County hosted many large and small farm holdings. Smaller ones, run by individual families, kept the families going, with produce sold at local markets and preserved through home canning and pickling. The Marotta farm was on North Adam Street.

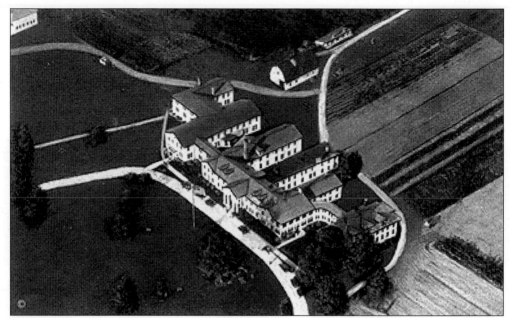

THE ODD FELLOWS FARM, AN AERIAL VIEW. This view shows the extent of the Odd Fellows Farm grounds. It was on Odd Fellows farmland, which once stretched all the way to Cold Springs Cemetery, that the Niagara grape was developed by Claudius Hoag.

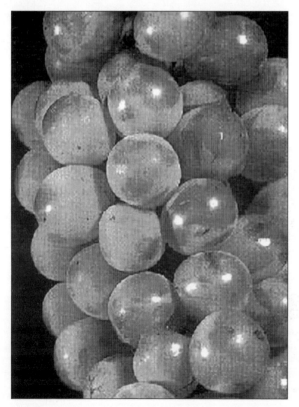

THE NIAGARA GRAPE. The Niagara grape is another innovation of which Lockport can be proud. The Hoag family developed the grape in 1868, formed the Niagara Grape Company in 1879, and promoted this famous product, which is used both in winemaking and as a dessert grape. The original vineyard was on the site of the Town and Country Club. The Hoags also developed Niagara Bitters.

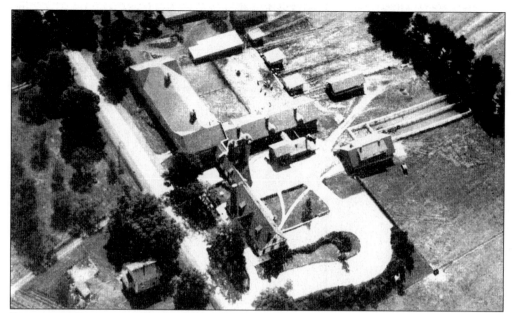

RANDLEIGH FARM, AN AERIAL VIEW. Located just three miles east of Lockport along Chestnut Ridge, Randleigh Farm was one of the most innovative scientific dairies of its day. Celebrated Lockport philanthropist William Rand Kenan Jr. bought the farm in 1921. His wife, Alice, coined the name Randleigh from Kenan's middle name added to "leigh," which she believed was Scottish for farm.

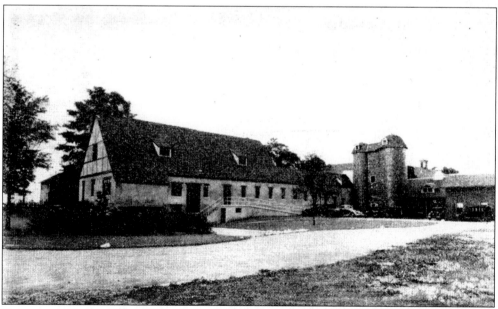

RANDLEIGH FARM, BACK VIEW. First and foremost, William Rand Kenan Jr. was a scientist. Although he knew nothing about the dairy business, he approached it with the same scientific method he applied to his work as a chemist. Already a multimillionaire through his work building acetylene gas plants worldwide and other successful business ventures, Kenan became intrigued by dairy cow breeding. He devoted many years to improving the quantity and nutritive quality of milk production.

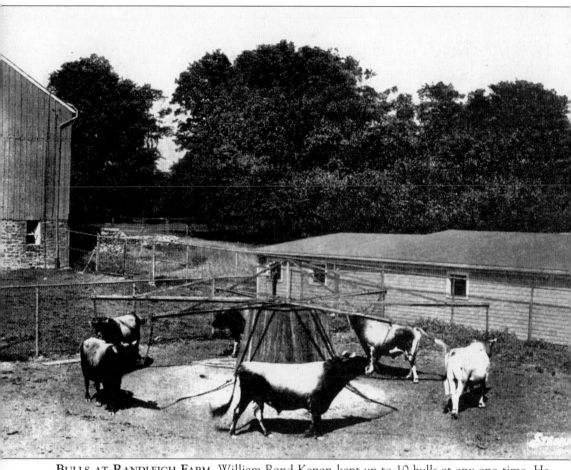

BULLS AT RANDLEIGH FARM. William Rand Kenan kept up to 10 bulls at any one time. He attributed their easy care to the fact that they got plenty of fresh air and exercise, especially after the development of this bull exerciser, which walked them around at the rate of three miles an hour, for two hours a day. Kenan, along with his managers, traveled all over America to acquire the best animals. As one of the world's richest men, he could afford to pay thousands of dollars for a cow or bull with a good pedigree.

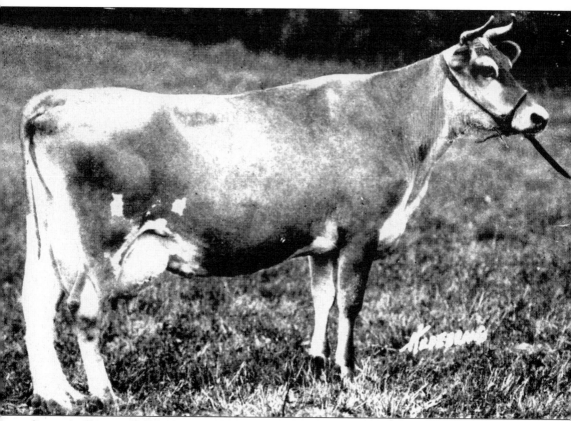

Sophie's Emily, Prize Cow. Kenan acquired Sophie's Emily from a farm in Lowell, Massachusetts. Although he emphasizing the high yield of his entire herd, he noted that this champion was the highest ranking Jersey cow in the United States for lifetime production: during nearly 15 years, she produced more than 143,000 pounds of milk.

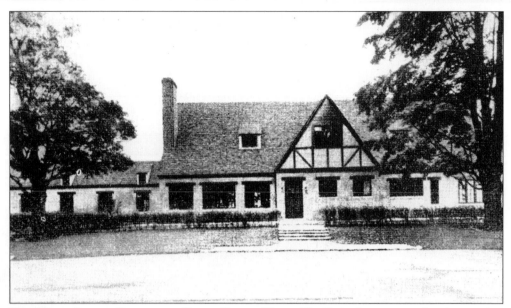

THE DAIRY INN AT RANDLEIGH FARM, FRONT VIEW. The Dairy Inn was another innovation of Randleigh Farm. Milking parlors were introduced in 1932, with individual stalls behind glass walls, where the cows were milked mechanically in public view. The Dairy Inn was also a retail store in which milk and rich delicious ice cream were sold. It was a place that became a popular field trip for many area elementary schools.

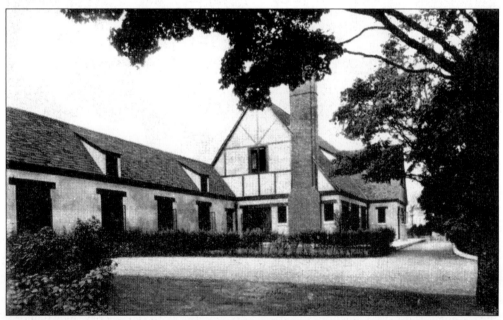

THE DAIRY INN AT RANDLEIGH FARM, SIDE VIEW. Customers would spend hours watching the cows being milked. William Rand Kenan made a special trip to Corning Glass works in Ithaca to develop large, sturdy glass jugs to collect the milk before it was quickly transferred into specially created refrigeration units to cool and maintain quality.

Five

SCHOOLS

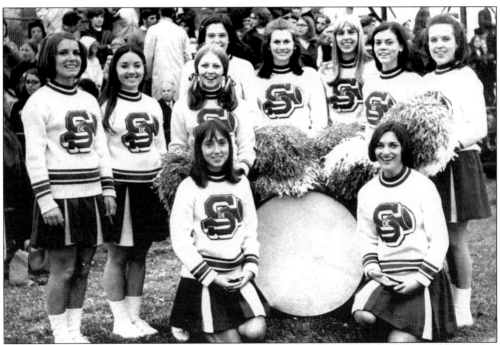

THE DESALES HIGH SCHOOL CHEERLEADERS, 1970. Shown are the varsity cheerleaders of DeSales High School in 1970. From left to right are the following: (front row) Sally Leichtnam and Donna Orsini; (back row) Ann Castle, Debbie Gustin, Kathleen Rooney, Judy Clifford, Joan Roberts, Joan Barry, Debbie Trumet, and Janet McKenna (captain). DeSales all-boys high school opened its doors to girls when St. Joseph's Academy for Girls closed in 1957. The Sisters of St. Mary Namur, however, educated girls separately.

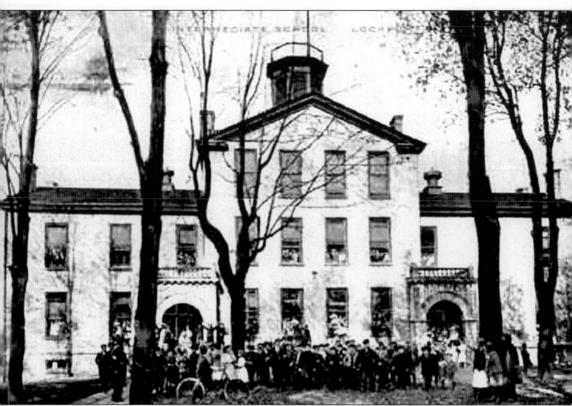

THE LOCKPORT UNION SCHOOL. The Lockport Union School opened on July 4, 1848. It is considered the first public high school in the United States. Some unsubstantiated claims have described it as the first public secondary school in the world. Before this time, public schooling only went up to the elementary level. There was a modest tuition of $2 charged per semester. The second Union School was built in 1891 at a cost of $130,000. It was enlarged in 1917 and demolished in 1952.

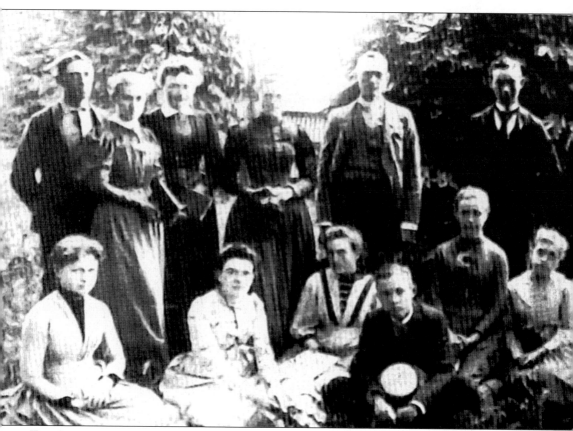

THE CLASS OF 1890. This is one of the last classes to graduate from the old Union School. The class motto was "Give us energy, stability, and success."

LOCKPORT HIGH SCHOOL. The Class of 1958 was the first to complete all three years at the new Lockport High School, which was built in 1954.

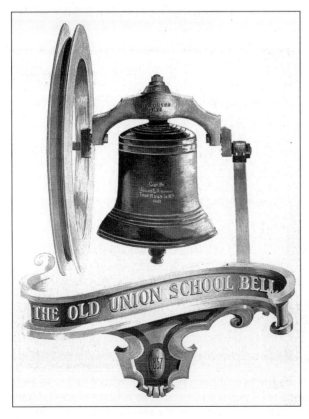

THE OLD UNION SCHOOL BELL. This symbol of the first Union School was cast in 1857. The first building was located at the corner of Chestnut and Washburn Streets. The school was rebuilt on East Avenue in 1891, across the street from where the public library now stands. This bell was moved to the new premises, but on the occasion of the 50th anniversary of the Union School, it was rehung in the old tower, where intermediate classes (sixth grade) had been held since 1893.

THE VINE STREET SCHOOL. This building began as a school—the first of the ward schools—in 1864. The land was bought from Gov. Washington Hunt. A very sturdy structure, it has served as a church and still stands today.

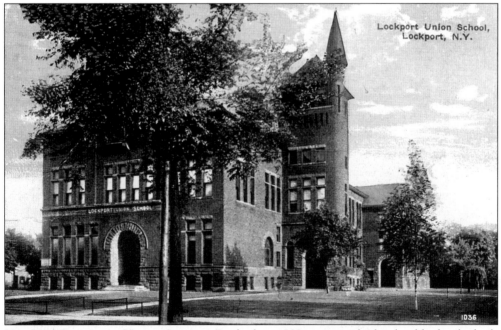

Lockport Union School,
Lockport, N.Y.

THE NEW LOCKPORT UNION SCHOOL. By the late 1880s, a newer high school had to be built to accommodate Lockport's growing number of pupils and its need to educate older children. The new high school was built on East Avenue and opened at the end of summer in 1891.

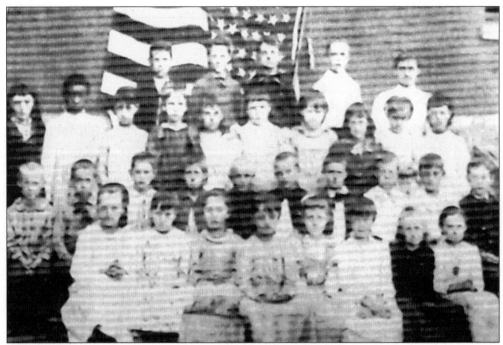

THE WASHBURN STREET SCHOOL THIRD GRADE. Also opening its doors in 1864, the Washburn Street School held the primary and secondary divisions. It was the first school to be fitted with central heating through the Holly system of district steam heating in 1877.

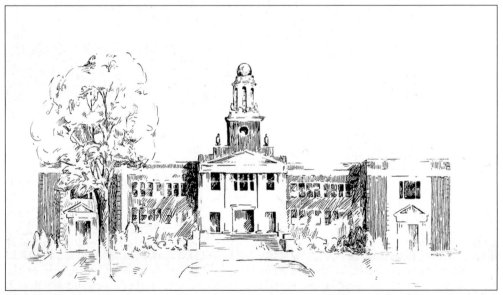

THE EMMET BELKNAP SCHOOL. Opened in 1925, the Emmet Belknap School was named after the former school superintendent. At first, it was an elementary school serving students through the sixth grade. In 1940, however, Emmet Belknap, along with North Park (built at the same time), expanded to become junior high schools. Today, they continue teaching the sixth, seventh, and eighth grades.

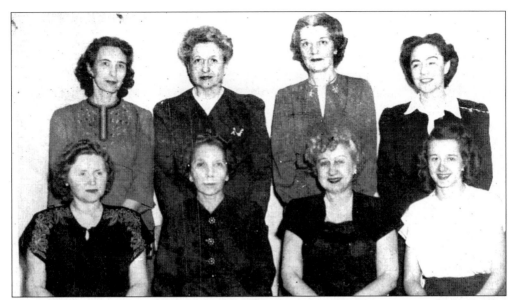

WASHINGTON HUNT TEACHERS. The Washington Hunt School, on Rogers Avenue, also opened in 1925, under the energetic building program of superintendent Roy B. Kelley. Margaret Spalding (front left) was principal in 1948. The school is located across the street from a city playground, one of many summer playgrounds initiated by the school system and later taken over by city government. The playgrounds provide work experience for young people and a supervised play area for children.

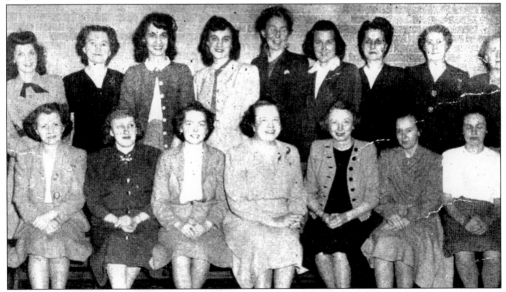

THE JOHN POUND SCHOOL. This elementary school on High Street was another of the city's older educational establishments rebuilt under Roy B. Kelley's superintendency. It reopened in 1930. The teachers, from left to right, are as follows: (front row) Lorraine Gardner, Lorraine Brady, Geraldine Gough, Margaret Armer (principal), Dorothy Joyce, Mirian Llewelyn, and Katherine Bracey; (back row) Sophie Barry, Alice Joseph, Pauline Trupiano, Josephine Trupiano, Dorothy Brown, Mary Ritzenthaler, Florence Blimm, Bessie Koithan, and Helen Whalen.

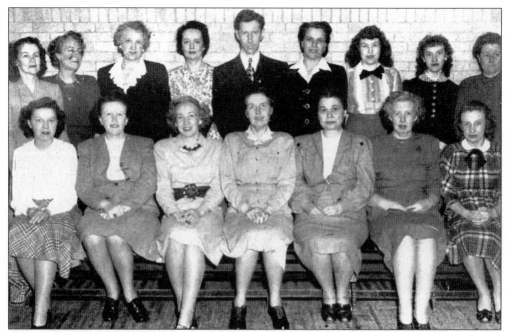

THE DEWITT CLINTON SCHOOL. Originating as the Clinton Street School, the DeWitt Clinton School was rebuilt from 1924 to 1925. Staff members of 1947 are, from left to right, as follows: (front row) Mary Murphy, Florice Burke, Agnes Gerrity (principal), Nellie Bullock, Mary Burke, and Helen Lippold; (back row) Kathryn Murphy, Salome Bowerman, Margaretta Hoenig, Marguerite Jones, Donald Nixon, Anna Peters, Grace Ganshaw, Antoinette Newton, and Helen Joustra.

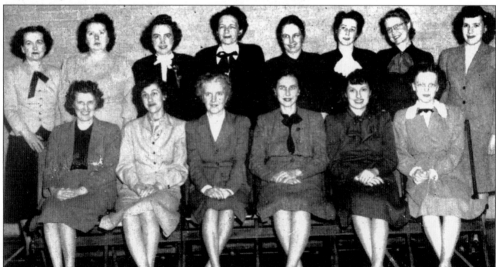

THE CHARLOTTE CROSS SCHOOL. Shown is the staff at the Charlotte Cross School in 1947. Principal Ruth Craig (fifth from the left in the back row) was named as Lockport's longest serving teacher (1859–1913). Women were prominent in school life and Lockport politics from the start. Another Lockport teacher, Belva Lockwood, was the first woman to run for president of the United States; she ran with the Equal Rights party. Charlotte Cross is now an alternative school for high-school aged students.

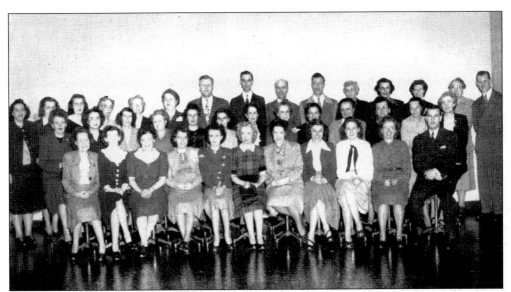

THE NORTH PARK SCHOOL. Principal Gordon Voght (back row, at the left) is pictured with his staff in 1947. This Passaic Avenue institution is now a middle school.

DeSALES HIGH SCHOOL. Shown during an early spring day is the students' entrance along Carlisle Gardens.

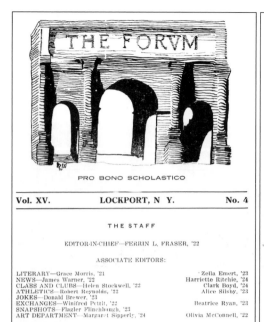

PRO BONO SCHOLASTICO

| Vol. XV. | LOCKPORT, N. Y. | No. 4 |

THE STAFF

EDITOR-IN-CHIEF—FERRIN L. FRASER, '22

ASSOCIATE EDITORS:

LITERARY—Grace Morris, '21
NEWS—James Warner, '22
CLASS AND CLUBS—Helen Stockwell, '22
ATHLETICS—Robert Reynolds, '22
JOKES—Donald Brewer, '23
EXCHANGES—Winifred Pettit, '22
SNAPSHOTS—Flagler Flinchbaugh, '23
ART DEPARTMENT—Margaret Sipperly, '24

Zella Emert, '23
Harriette Ritchie, '24
Clark Boyd, '24
Alice Silsby, '23

Beatrice Ryan, '23

Olivia McConnell, '22

SCHOOL ACTIVITIES. The 1922 Lockport High School Forum Magazine (left) was the precursor of the traditional high school yearbook. It includes an exhaustive account of the 1922 academic year's events, including fire drills, dramatic presentations, and personalized quotations for each of the graduates. The *Belknap Beacon* was a similarly longstanding school magazine. A popular event at DeSales High School was spring musical presented by the DeSales Players, which in this case was *Carousel* (right).

DE SALES SPORTS BOOSTERS

Present

ANNUAL SPORTS NIGHT

HONORING

THE
LOCKPORT POLICE DEPT.

ON LAW AND ORDER

"If someone invades your home, do you dialogue with him or call the law? Without the law, the university is a sitting duck for any small group from outside or inside that wishes to destroy it, to incapacitate it, to terrorize it at whim. The argument goes — or has gone — invoke the law and you lose the university community. My only response is that without the law you may well lose the university — and beyond that — the larger society that supports it and that is most deeply wounded when law is no longer respected, bringing an end of everyone's most cherished rights."

SPORTS AWARDS. Shown is a Lockport Public School Basketball Award (left), a memento from the sixth grade's recreational play day. The day offered competition in gym events for the city's girls and boys. The DeSales Annual Sports Night (right) was held by the DeSales Sports Boosters to pay tribute to the community and to raise vital funding for the school. DeSales weathered many financially difficult years until it closed as a high school in 1989. Several years later it reopened as an elementary school (kindergarten through eighth grade). Although it charges tuition fees, DeSales still relies on fund-raising events to keep its doors open.

76

Six

THE ERIE CANAL

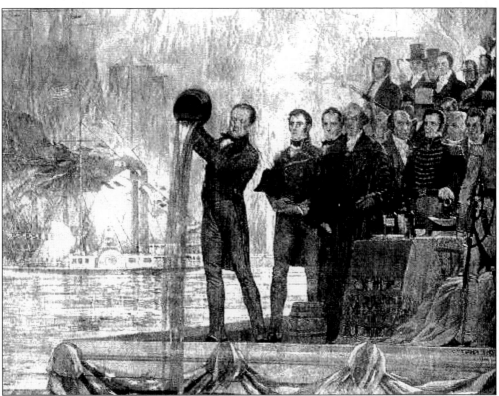

THE MARRIAGE OF THE WATERS. It took eight years to complete the Erie Canal, from July 4, 1817, until the *Niagara* sailed through on October 26, 1825. The boat was captained by daredevil war hero Gen. Peter Porter. Shortly afterward, Gov. DeWitt Clinton, on the *Seneca Chief*, carried two kegs of Lake Erie water and poured them into the Atlantic at the end of the voyage. This 1905 painting, *Marriage of the Waters*, by Charles Yardley Turner, commemorated the event.

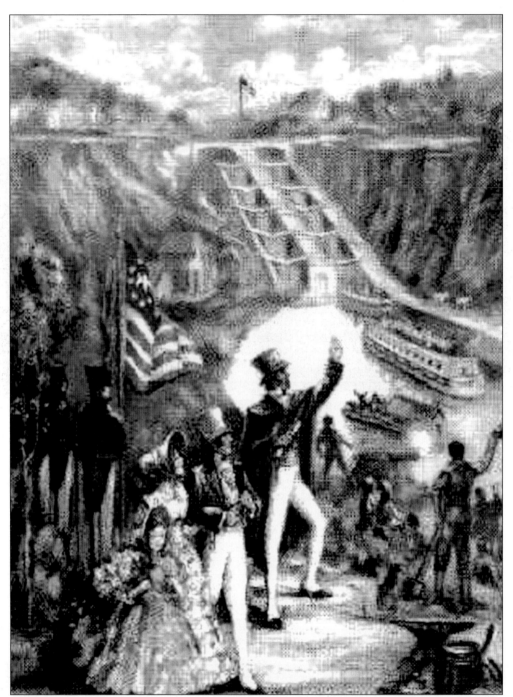

THE OPENING OF THE ERIE CANAL. For Lockport's opening ceremony on October 26, 1825, local orator John Birdsall stood on a canal boat deck above the locks to announce, "The last barrier is removed!" Two years earlier, he had stood on locks foundation stone to herald the start of the works. Lockport artist Raphael Beck (1858–1947) memorialized the event with a large mural for Lockport Exchange Bank (later Manufacturers & Traders Trust Company). The mural now hangs in Lockport High School.

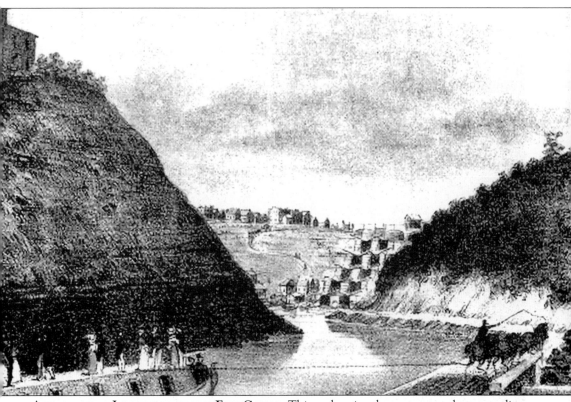

APPROACHING LOCKPORT ON THE ERIE CANAL. This early print shows a narrow boat rounding the bend near where Widewaters Marina now stands, with the flight of five locks in the distance. In 1825, Lockport was only a very small settlement, with a population of 2,500. Canal trade brought immediate prosperity. Timber was exported, and luxuries from around the world were imported, transforming life in the community.

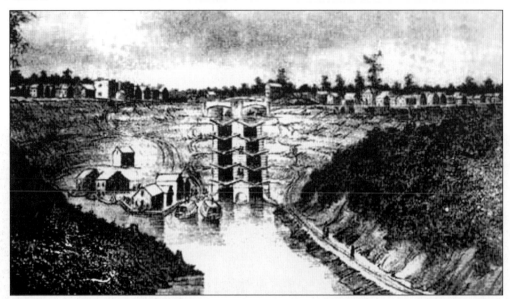

EARLY LOCKPORT AND THE FIVE LOCKS. This view shows the towpath on the right and the beginnings of Market Street winding up hill from the canal basin on the left. The canal stretched 363 miles and was 40 feet wide and 4 feet deep. It was achieved almost entirely by the muscle, skill, and perseverance of largely Irish navvies. Their contribution to the creation and development of Lockport is recognized in a monument on the Big Bridge, erected by the Ancient Order of Hibernians.

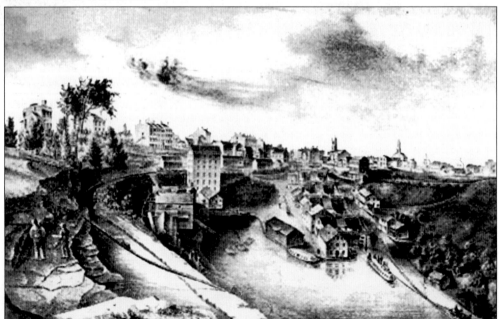

LOCKPORT, 1830. Lockport had developed considerably by 1830, thanks to the hydroelectric potential unleashed by the falling waters of the locks. Albany businessmen bought up the surplus water rights and built raceways to encourage industry. Mills were built, and Lowertown was laid out. The first bank was established, and Lockport village was incorporated in 1829. Lockport served as the hydroelectric powerhouse until surpassed in 1880 by Niagara Falls.

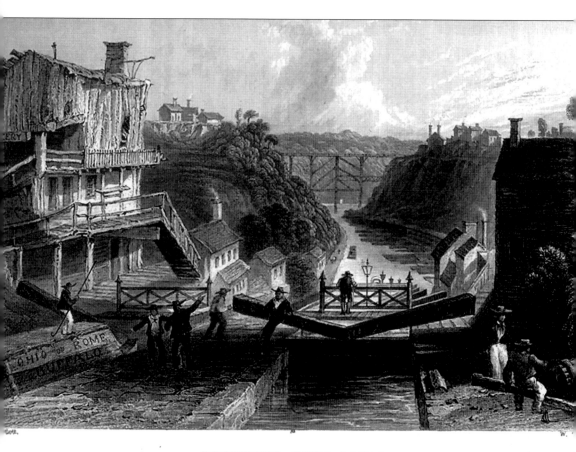

LOCKPORT, ERIE CANAL.

LOCKPORT CANAL ERIE. DIE STADT LOCKPORT UND DER CANAL ERIE.

BARTLETT'S LOCKPORT. This famous 1839 engraving of the locks depicts a rather ramshackle Lockport. Idle men laze about when, in fact, Lockport was bustling and growing fast, with a population of 9,000. The engraver, William Bartlett, was a well-known English artist who traveled extensively in Europe, the Middle East, and America, producing fine drawings that were later made into prints and published for the new middle-class Victorian audience eager to see pictures of the world.

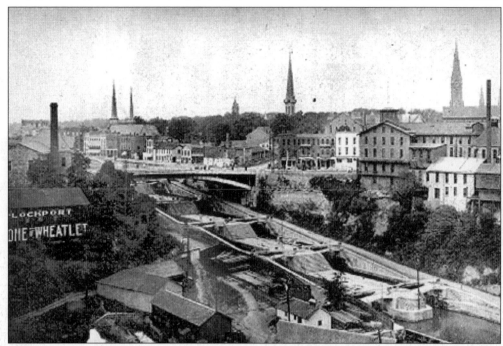

A VIEW OF THE LOCKS, FROM THE SOUTH. The advertising seen on the left of this *c.* 1900 view of the canal shows "Lockport, Home of the Wheatlet," a popular cereal produced by Franklin Mills Company. One of the earliest and largest flour milling businesses on the canal, the company's large factory burned down in 1907.

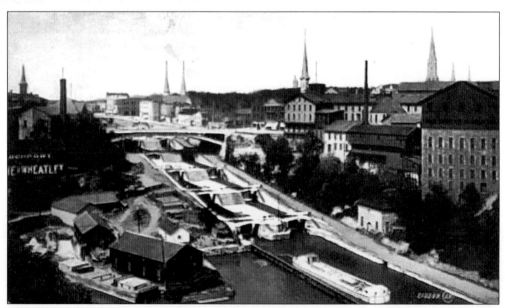

A LATER VIEW OF THE LOCKS. This similar view dates from before 1908. It shows a skyline dominated by church spires, with St. Mary's on the far left and St. Patrick's on the far left.

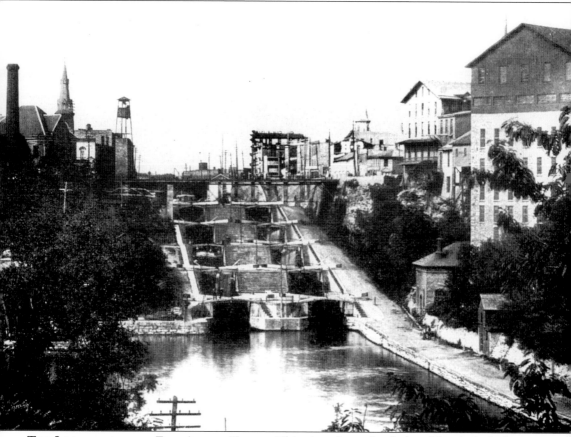

THE LOCKS, WITH THE FIRE ALARM TOWER. This view shows the flight of five locks before they were enlarged between 1908 and 1918. In the upper left, the fire tower can be seen.

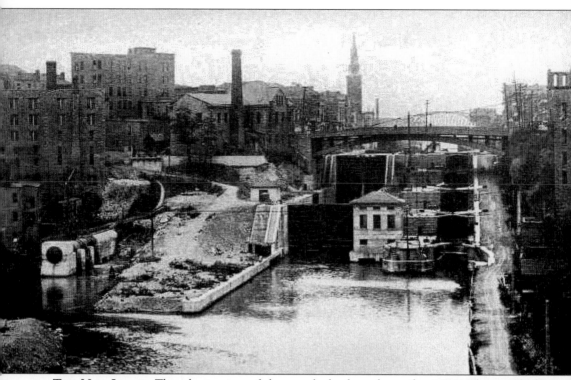

THE NEW LOCKS. This classic view of the new locks dates from after 1918. The new locks sit next to the "flight of five" locks. The small building in between has served for years as the Canal Museum.

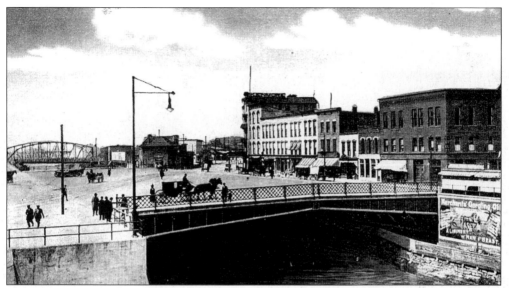

THE BIG BRIDGE, LOOKING WEST. A 40-foot-wide wooden bridge replaced the original narrow bridge over the canal in 1843. In 1914, the Big Bridge was constructed. It was an engineering feat, spanning 105 feet. It remains one of the world's largest bridges. A Merchants Gargling Oil advertisement is visible in the lower right.

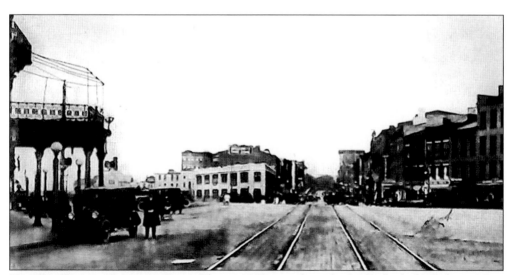

THE BIG BRIDGE, LOOKING EAST. This c. 1910 view from the bridge looks back down Main Street. Bayliss Drugs can be seen in the middle distance, and the Farmers & Mechanics Bank is visible at the far end of Main Street.

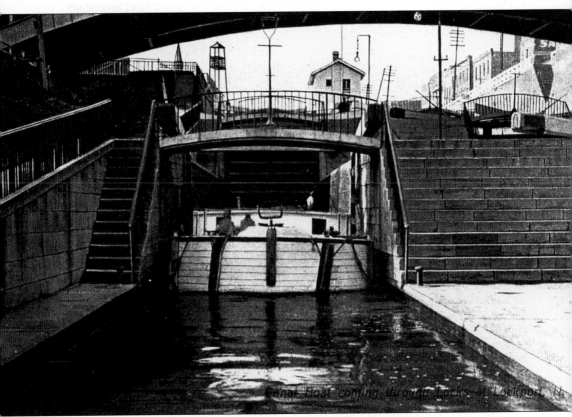

THE LOCKS, 1910. This splendid view shows the locks just before they were enlarged.

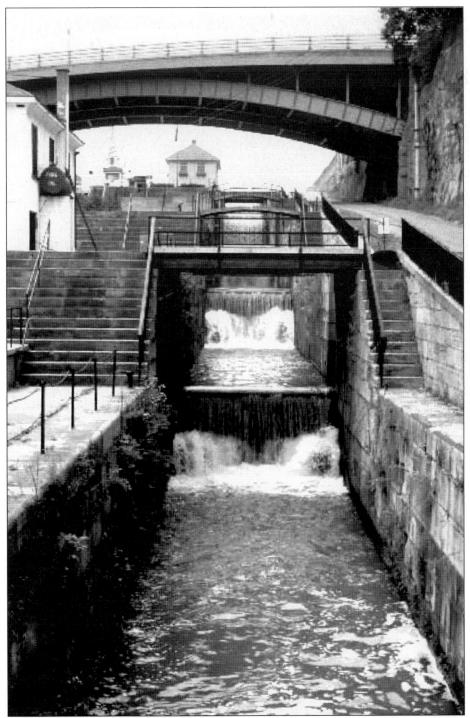

A Canal Boat Coming through Lockport. The original canal could only take boats of 75 tons. So, the canal was enlarged several times to accommodate increased trade. The last enlargement was done between 1908 and 1918 by thousands of immigrants from Italy who settled in Lockport.

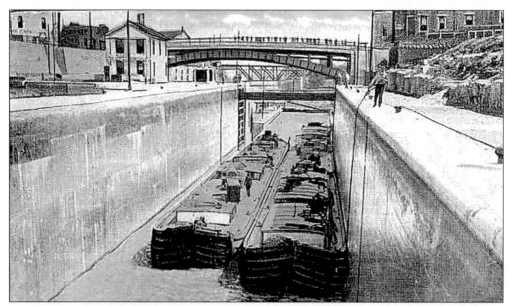

LIFT LOCKS AND THE BARGE CANAL. Many canals were built during the craze that followed the success of the Erie Canal. The arrival of the railroad ended the craze, but the Erie Canal remained profitable. Barges of 2,000 tons could use the canal and, by the 1950s, five million tons of goods were transported by what was then renamed the New York State Barge Canal. The canal is now important for tourism.

THE FIVES. One flight of the original 1825 flight of five locks remains as a tourist attraction and spillway.

Seven

CHURCHES

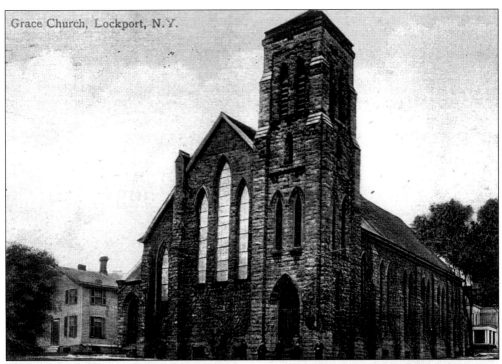

Grace Church, Lockport, N.Y.

GRACE CHURCH. This Episcopal church was organized in 1835, and its first building was completed on Buffalo Street the following year. The new Grace Church was built on the corner of Genesee and Cottage Streets in 1855.

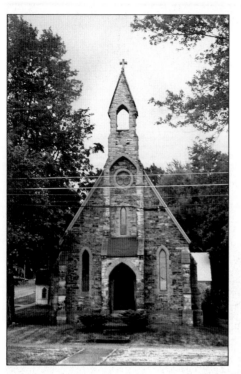

CHRIST EPISCOPAL CHURCH. Established at the corner of Market and Vine Streets in 1838, the present Christ Episcopal Church building dates from 1855. Its distinctive appearance has given rise to local legends including one tale, still told, that the church was built by an English emigrant for his wedding, as he was pining for a reminder of his homeland.

THE FIRST ENGLISH LUTHERAN CHURCH. This commemorative plate bears an image of the First English Lutheran Church, on Locust Street. The original wooden and brick structure was built in 1837, substantially remodeled in 1918, and completely rebuilt in 1952.

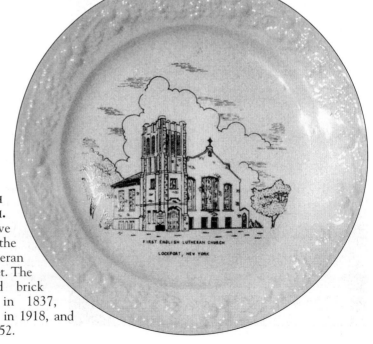

THE METHODIST AND CONGREGATIONAL CHURCHES. The Quakers were the first to build a church in Lockport, in 1819. The Methodists were not far behind, holding meetings in various locations before building this elegantly spired structure on Church and Niagara Streets. The first Congregational church was built in 1838, and the church on the left was later transformed rather incongruously into the Ford Gumball Factory. It no longer stands.

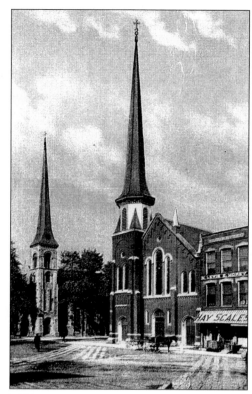

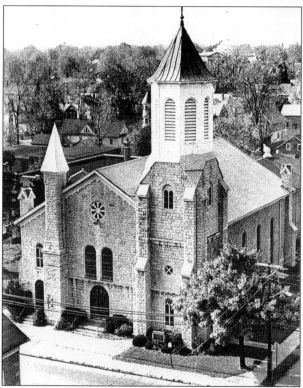

THE FIRST PRESBYTERIAN CHURCH. This handsome Church Street building began life as a log cabin in 1823—a year after the congregation was organized. In 1855, the present stone building was constructed from local Lockport stone, and the elegant belfry was added in 1867. The church is perhaps best known for its extremely rare Tiffany glass windows, which draw connoisseurs from far and wide to view this downtown landmark. Malbie Babcock, renowned hymn writer, was pastor here from 1882 to 1887.

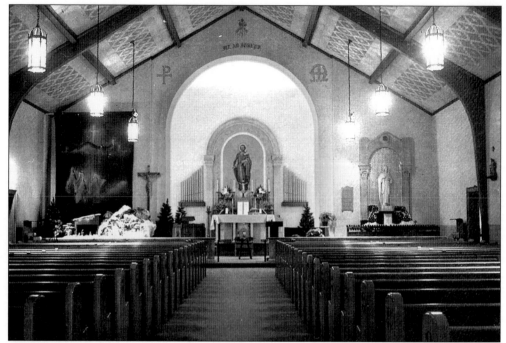

ST. JOSEPH'S CHURCH. This church and St. Anthony's were the local Italian Catholic churches. St. Joseph's was for the Calabrese of Lowertown, and St. Anthony's was for the Abruzzese of downtown Lockport. St. Joseph's was established on the corner of Adam and Garden Streets in 1912 to serve the rapidly growing Italian community that had come to the area to help widen the Erie Canal. The new church on the corner of Market and Adam Streets was consecrated in 1956.

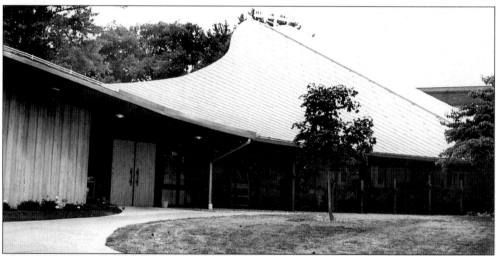

ST. JOHN'S CHURCH. Together with St. Patrick's, this church has long served Lockport's Irish-American community. St. Mary's catered to the German settlers. Today, the congregations are from many backgrounds. St. John's was the first; it was built on Chestnut Street in 1834. St. Patrick's followed, built from 1858 to 1863. The landmark tower was added in 1902. St. Mary's went up at almost the same time, opening in 1858. Recently, St. John's was been rebuilt in a modern style, with a roof that curves over the congregation like a great wing.

Eight
LEISURE

LOCKPORT TOWN AND COUNTRY CLUB, 1950. These lush landscaped golf grounds were originally the vineyards of the Odd Fellows farm that grew Niagara grapes. The very exclusive club, which originated in premises on the Hill, has always enjoyed status as the city's premier social facility. It has in recent years broadened its membership.

THE TUSCARORA CLUB. Tucked away on Walnut Street, this magnificent colonnaded building is another venerable Lockport institution, the Tuscarora Club. Today, it continues to serve as an upscale meeting place for business organizations in the region.

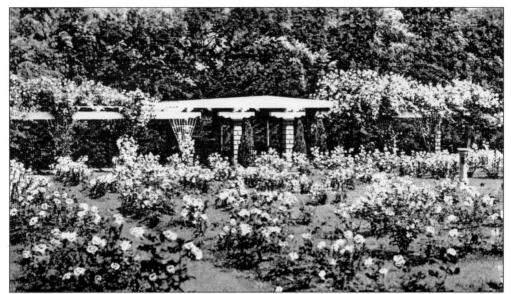

THE ROSE GARDENS, OUTWATER PARK. Outwater park is known not only for fine floral displays but also as one of the city's best-loved open spaces. Its pool and magnificent views across Lake Ontario to Toronto have been enjoyed by generations of Lockportians. The park was named and donated to the city by Dr. Samuel Outwater (1868–1953), a Lockport doctor who lived at 215 Niagara Street. Outwater's home was bequeathed to the Niagara County Historical Society, and it is now the society's museum.

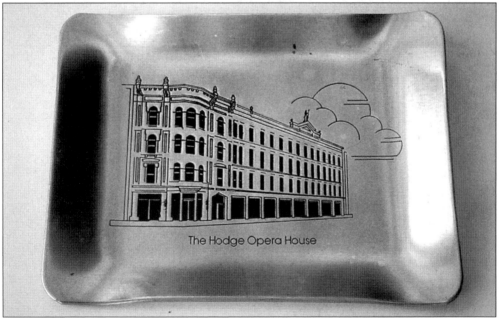

The Hodge Opera House

THE HODGE OPERA HOUSE. Opened on November 5, 1872, on the site of the Tucker Building, the Hodge Opera House was financed by John Hodge, who made a fortune from Merchant's Gargling Oil. Many of the nation's finest actors performed there. It was rebuilt after a serious fire in 1881 and continued as a cultural haven until it burned down in 1928. From the back of the Bewley Building, which replaced it, sections of the old opera house walls are still visible.

THE YMCA. Lockport's YMCA was organized in 1861 and incorporated in 1866. The headquarters opened on East Avenue in 1902 and was substantially enlarged in 1910. Its swimming pool and other leisure facilities have been immensely popular with Lockportians of all ages for decades.

A DIRECTORY AND A PROGRAM. Early Niagara County directories included elaborate instructions on "how to unpack a piano" (left), together with "hints on the preservation of the piano." The 1869 edition notes that "cheap pianos, with which the country is flooded, are invariably the most expensive in the end." The 1925 Official Program of Old Home Coming Week (right) details the festival that commemorated the canal's centennial. The week began with all the factory whistles in the city, which were numerous, blowing for three minutes. Events included a school parade, a pageant on the theme of public education, a monster decorated automobile parade, a military parade, a historical pageant, and a civic and fraternal day parade—the largest and longest procession ever witnessed in the city of Lockport.

OUTDOOR EVENTS. The Father's Day Picnic (left) held at Tall Pines, out toward Pendleton, was always well attended. Pulaski clubs—originally founded to honor Count Pulaski, a Polish nobleman who fought alongside Washington—are some of the oldest social organizations in the Unites States and had many adherents in nearby Buffalo. The Boat Ride through the Locks (right) was also a popular event. While freight barges still move through the canal, tourism has become its main activity. Canal boat outings have become increasingly popular since the Lockport canal side was landscaped in the 1990s.

HOMECOMING DAY, DESALES HIGH SCHOOL. This decorated float, part of the 1969 annual Homecoming parade, is heading toward the DeSales football field, on Davison Road across from the golf course. Today, DeSales High School no longer exists and the Bonner Drive and DeSales Circle area is residential.

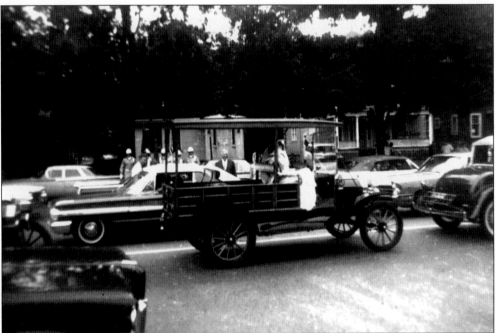

THE MEMORIAL DAY PARADE. Another Lockport tradition, which continues today, is the Memorial Day parade. The length and content of the parades is scrutinized by city residents—especially those who live on East Avenue. The one shown began at Main Street and ended at East Avenue Park (now Veterans Memorial Park).

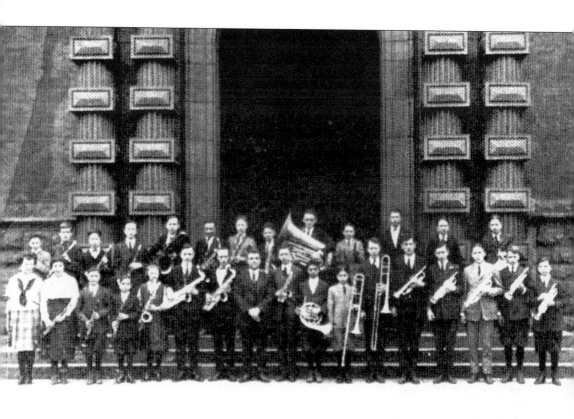

THE LOCKPORT HIGH SCHOOL BAND, 1922. A strong musical tradition in Lockport schools began in the city's early days. The National Music Festival was organized by A.A. Vandemark in 1905.

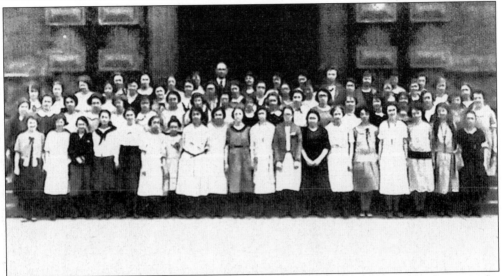

THE LOCKPORT HIGH SCHOOL GIRLS' CHORAL CLUB, 1922. On May 25 and 26, 1922, the Lockport High School Girls' Choral Club performed the operetta *The Fire Prince,* to great acclaim. Members included Anna Bartenstein, Dorothy Brumley, Ruth Brees, Helena Burke, Beulah and Harriet Charles, Doris Clark, Margaret Conley, Loraine Johnston, Gertrude Jones, Dorothy Joyce, Marian Kinzly, Grace Leinbach, Marian Mitchell, Elizabeth Moyer, Helen Orr, Winifred Pettit, Louise Proctor, Helen Shaft, Bernice Shimer, Althea Singleton, Dorothy Smith, Bernice Spaulding, Lois Sprout, Helen Stockwell, and Elizabeth Stuart.

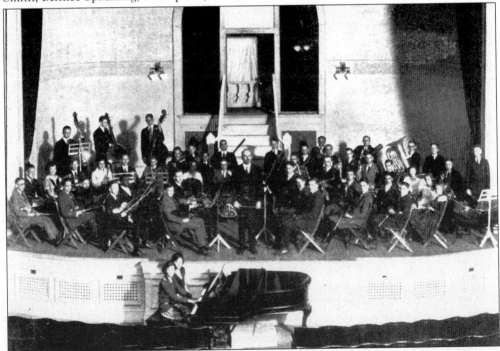

THE LOCKPORT HIGH SCHOOL ORCHESTRA, 1922. The Lockport High School director of music between the wars was Earl W. Haviland. Public performances of the 50-piece orchestra raised hundreds of dollars for the purchase of musical instruments for the school.

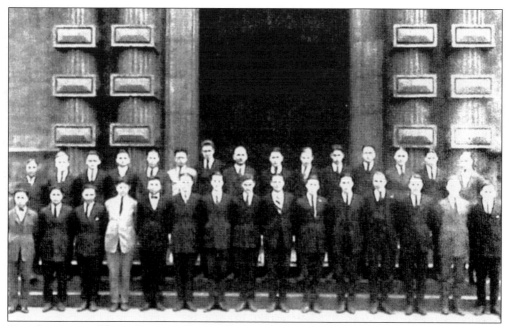

THE LOCKPORT HIGH SCHOOL BOYS' GLEE CLUB, 1922. Members of the club included Anthony Barone, Carl Bryant, Charles Dickinson, Leslie Ferris, Ferrin Fraser, Merrill Hollinshead, Clayton Kohler, Herbert Lloyd, Joseph Madden, Carl Quagliana, Robert Reynolds, Dudley Walker, and James Warner.

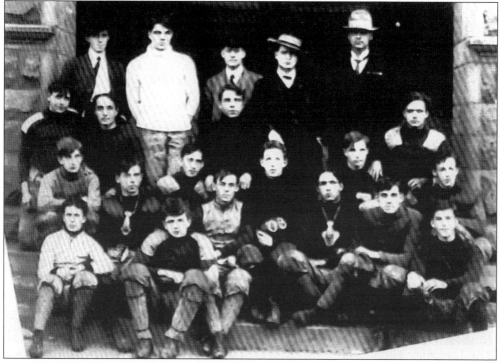

THE LOCKPORT HIGH SCHOOL FOOTBALL TEAM, 1903. The team lines up at the school's main entrance, wearing gear that provided modest protection from the rigors of the game.

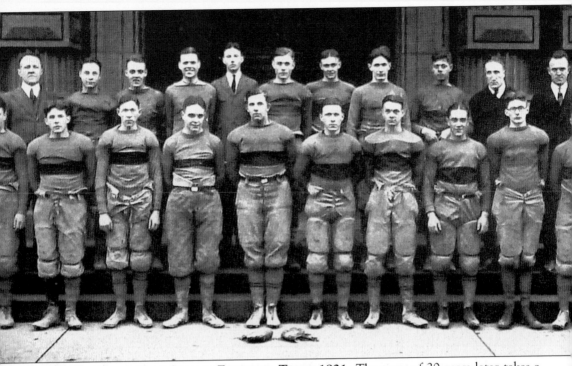

THE LOCKPORT HIGH SCHOOL FOOTBALL TEAM, 1921. The team of 20 years later takes a more formal pose, looking marginally better padded. The season was not a successful one. On the team were Brewer, Fereney, Ferris, Fowlie (captain), Gooding, Hoenig, Kinzly, Leonard, Lloyd, Marantette, Ormiston, Reynolds, Russell, Salmiri, Snediker, Stazer, Steritt, Walls, Wyles, and R. Wyles.

DeSales Knights Football, c. 1970. Teams were strongly supported by families, pupils, staff, and alumni, despite often inclement weather. Most games were broadcast locally on WUSJ AM radio.

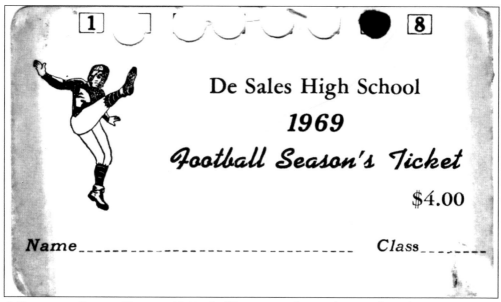

1

8

De Sales High School

1969

Football Season's Ticket

$4.00

Name_____ Class_____

A Football Season Ticket, 1969. At 50¢ a game, this is a bargain from the past.

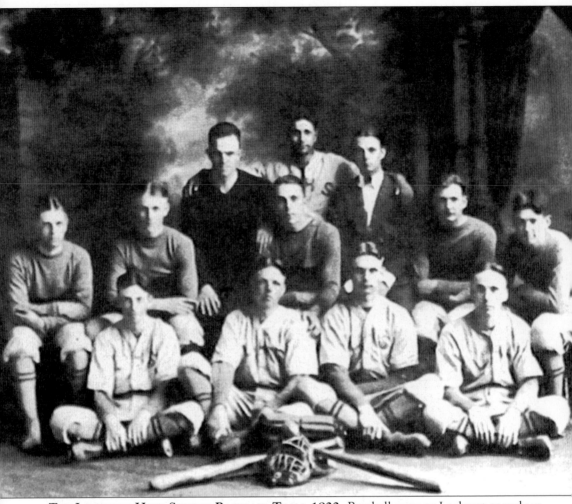

THE LOCKPORT HIGH SCHOOL BASEBALL TEAM, 1922. Baseball came to Lockport as early as 1858, when the newly established Lockport baseball team played in Courthouse Square. The team included Charles Dickinson, Ferrin Fraser, and Herbert Lloyd.

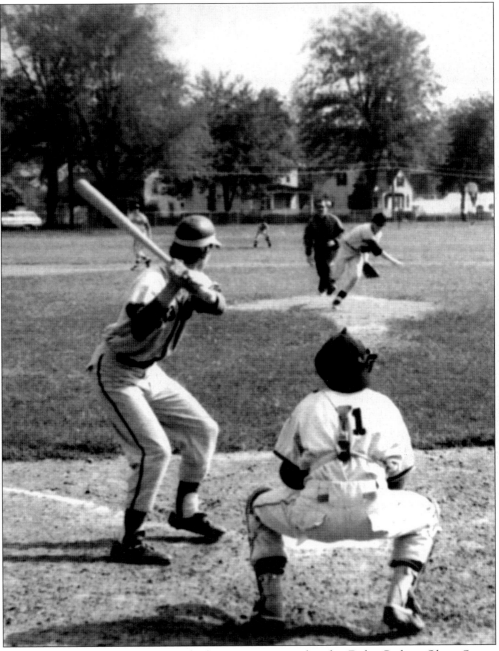

DeSales Baseball, c. 1970. DeSales home games were played at Dolan Park on Olcott Street.

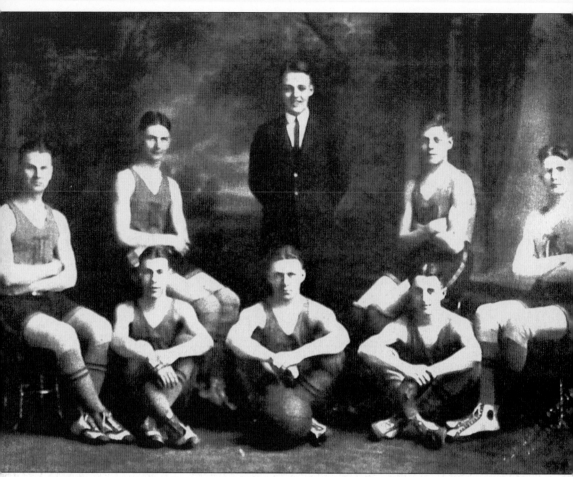

THE LOCKPORT HIGH SCHOOL BASKETBALL TEAM, 1922. Some of the players on the team were Allen, Dickinson, Gooding, Hull, Johnston, Krinke, Lloyd, Marantette, Ormiston, Phillips, Reynolds (captain), Thurmiston, Walls, and Wyles.

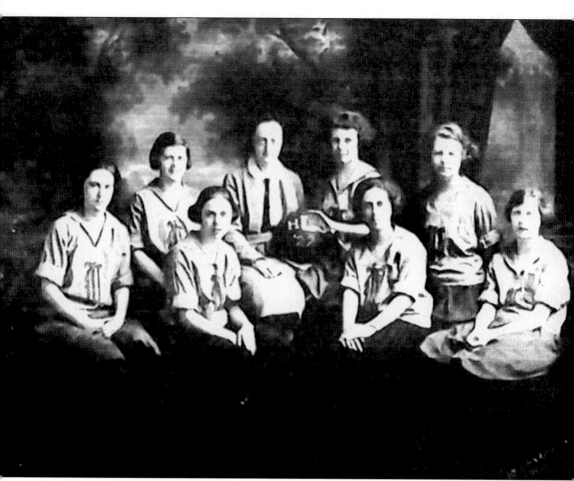

THE LOCKPORT HIGH SCHOOL GIRLS' BASKETBALL TEAM, 1921–1922. Unlike the boys' team, the Lockport High School girls' team had a moderately successful season, winning six out of twelve matches in the 1921–1922 season. Players included Diedra Harwood, Olivia McConnell, Kathleen McGinness, Betty Moyer, Helen Orr (captain), Dorothy Spalding, and Marjorie Wiseman.

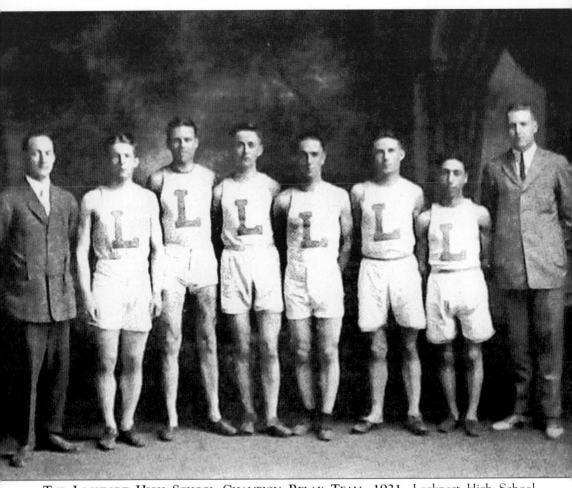

THE LOCKPORT HIGH SCHOOL CHAMPION RELAY TEAM, 1921. Lockport High School excelled at track events during the interwar years. The team traveled as far as Toronto to show off its skills.

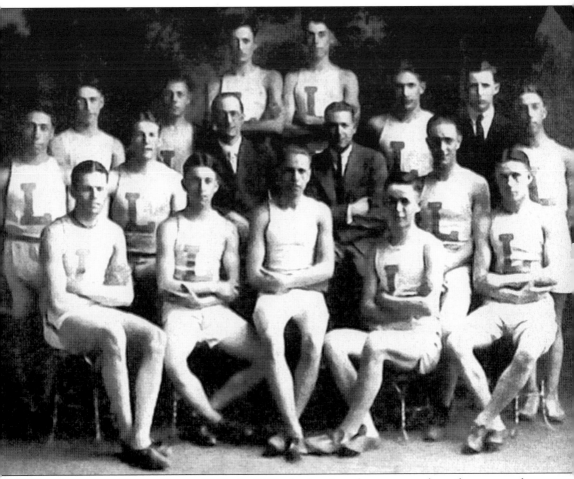

THE LOCKPORT TRACK TEAM, 1922. In 1922, the boys' track team won the mile event and the relay race at the Niagara County meet and came second and third in the high jump.

THE EMMET BELKNAP SCHOOL'S THURSDAY GYM CLUB, 1941. Englishman A.E. Gay, then director of physical education, revolutionized school sports in Lockport. He campaigned for a gym in every school and pointed out that "recreation . . . is a valuable medium when properly conceived and supervised, through which wholesome social attitudes can be taught."

A LOCKPORT TASTING SPREE.
Lockportians love their food. They
have benefited from a rich culinary
heritage, with Irish, Italian,
German, and Polish cuisine, and
they have enjoyed a wide variety of
local produce. The local calendar is
punctuated with traditional events
reflecting this rich harvest.
Strawberry teas, apple and corn
harvests, and peach festivals all
make for a mouth-watering year-
round bounty.

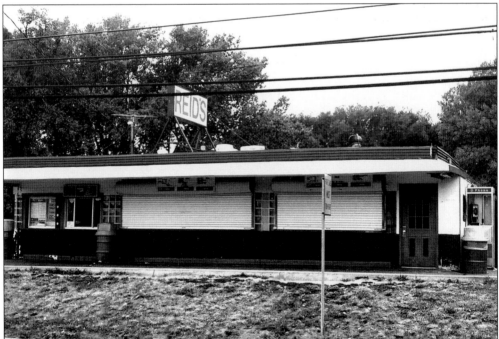

REID'S, LAKE AVENUE. Dishing up white hots with sauce to several generations of hungry Lockportians, Reid's has popularized what was originally a Rochester specialty. White hots are subtly spiced pork, veal, and beef wieners. Reid's is also well known for its soft ice cream, or custard.

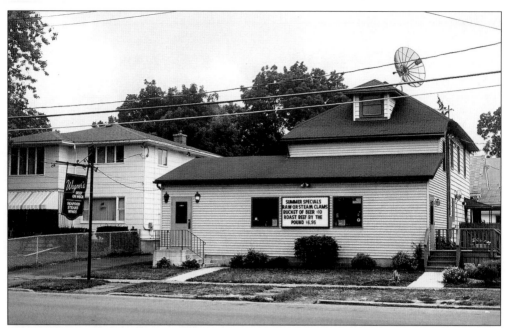

WAGNER'S, PARK AVENUE. Another trademark food specialty of western New York is beef on weck: thinly sliced roast beef on a Kummelweck bun, served with a dollop of horseradish. The bun is a Kaiser roll topped with cornstarch, pretzel salt, and caraway seeds. Wagner's has long been the place in Lockport to enjoy this local delicacy.

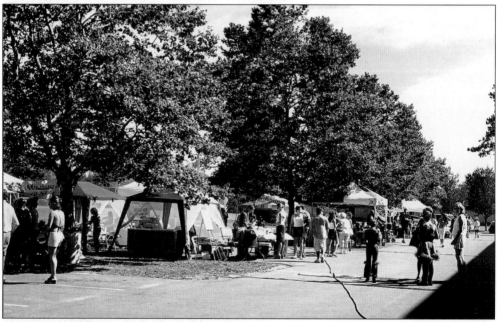

THE GARLIC FESTIVAL. Italian-American culture is celebrated in this annual summer event, which takes place at St. Anthony's Church. It boasts not only a wide selection of Italian desserts and savory foods (many including a hefty amount of garlic), but also competitive bocce, dancing, and spaghetti-eating contests. There is also a complementary Italian festival held annually at the Kenan Center.

Nine
NOTABLES

DEWITT CLINTON (1769–1828).
Although not from Lockport, DeWitt
Clinton is, arguably, the most
important person in its history. He was
a member of New York State's Canal
Commission from 1810 to 1824, and it
was his strong leadership and ability to
galvanize public support that led to the
Erie Canal's eventual construction. As
a result, he became governor of New
York from 1817 to 1823 and again
from 1825 to 1828.

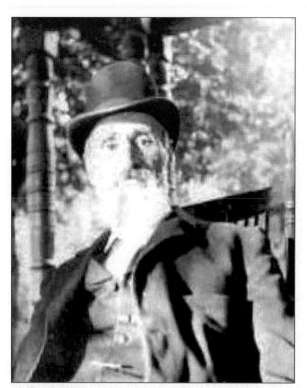

BIRDSALL HOLLY (1820–1894). Birdsall Holly, an innovative entrepreneur and industrialist, moved to Lockport from Seneca Falls in 1859. At that time, he was manufacturing sewing machines. As mentioned earlier, Holly developed modern firefighting, with his fire hydrants and pumping stations. After this hugely successful business, he developed steam heat into the first district central heating system. His American District Steam Company, founded in 1876, offered this system to Lockport's school district in 1877.

THE SEVEN SUTHERLAND SISTERS. The seven Sutherland sisters made their fortune from locks of a different sort—their magnificent long hair. The length of their combined tresses stretched 37 feet. A genius in late-19th-century marketing, their father concocted a popular hair growth tonic that made the family $2.75 million over 38 years. Born in Cambria, five of the sisters—Isobel, Naomi, Grace, Sarah, and Mary—are buried in Glenwood Cemetery.

OTHNIEL MARSH (1831–1899). A giant in the world of dinosaurs, Othniel Marsh was born in Lockport in 1831. He was the first person to name and describe triceratops, stegosaurus, and diplodocus. For one dinosaur, he provided two names: apatosaurus (accepted) and brontosaurus (now unaccepted). The Peabody Museum of Natural History holds his mammoth and influential collection of fossils and dinosaur bones. His uncle, George Peabody, was his main benefactor.

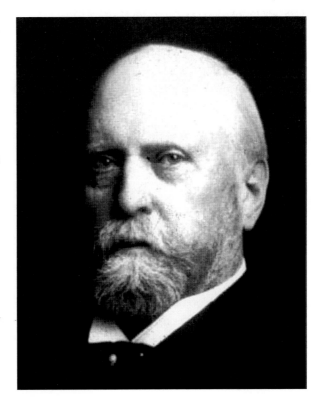

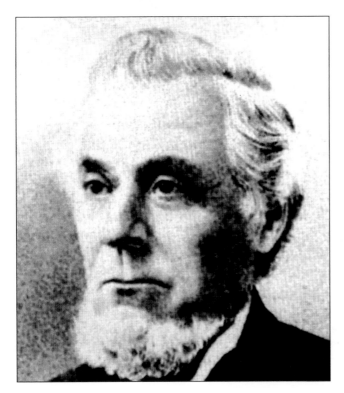

SULLIVAN CAVERNO. Sullivan Caverno was a prominent Niagara County educator who served two years as principal of the old Lewiston Academy. He went on to study law, using his legal skills to expand the public education system, which up to that point included only elementary school. In 1847, he wrote the act, passed by the New York State legislature, to create the Union School. This became America's first public high school.

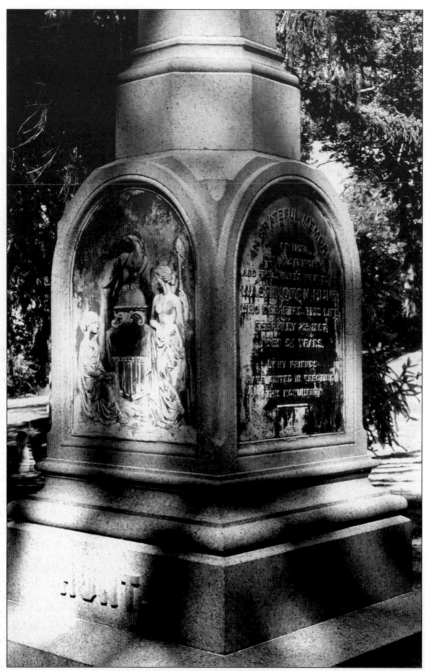

THE TOMB OF WASHINGTON HUNT. Now buried in Glenwood Cemetery, Washington Hunt (1811–1867) set up his law practice in Lockport. He and his father-in-law, Henry Walbridge, made a fortune on the thousands of acres they bought and later sold at a vast profit from the Holland Land Company. Hunt was a three-term congressman, and he served as the governor of New York from 1850 to 1852. The elementary school named after him is on Rogers Avenue.

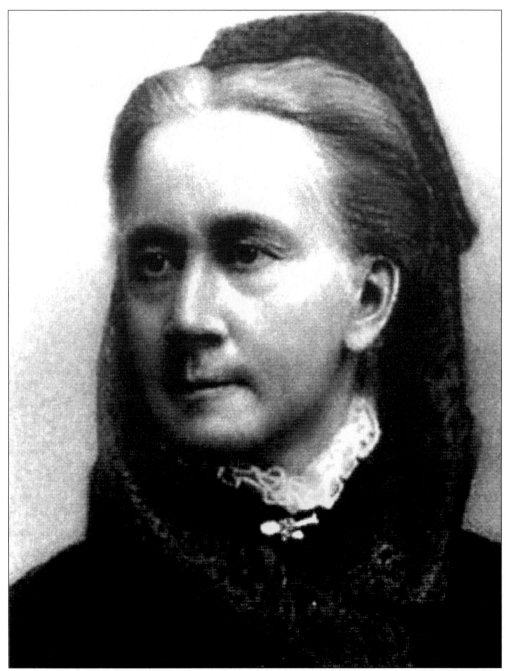

BELVA LOCKWOOD. Belva Bennett McNall Lockwood (1830–1917) was born in Royalton. She became preceptress of Lockport Union School in 1857, and she taught there for three years. She was the first woman to receive a law degree from a national law school, the first to practice law before the Supreme Court, and the first to run for president of the United States in 1884 and 1888. She ran under the Equal Rights party.

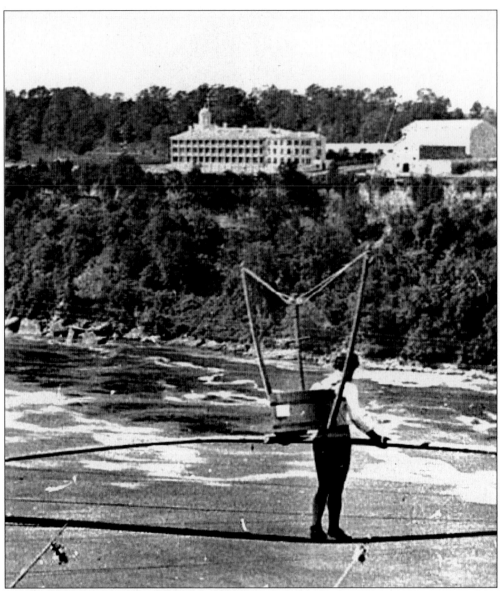

WILLIAM HUNT, THE GREAT FARINI. Guillermo Antonio Farini (1838–1929) was one of the most extraordinary characters in Lockport history. Born William Hunt in Lockport, his daredevil career began in Ontario, Canada, where he grew up. Farini was a master of death-defying acts, including a tightrope walk across Niagara Falls. He amazed millions worldwide, became an impresario of talented daredevils, launched the first human cannonball, used the first parachute, and was also a successful inventor, writer, and artist.

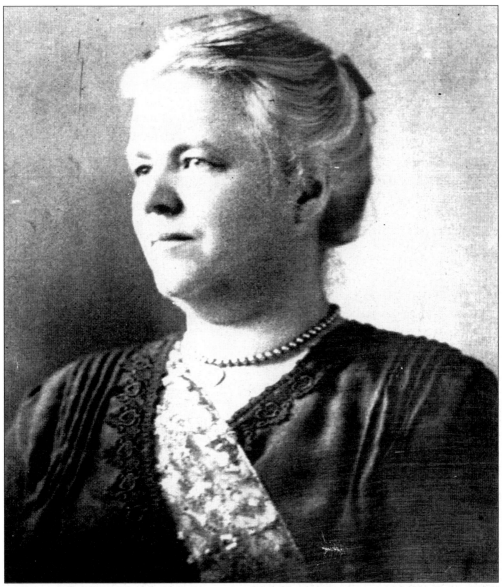

ANNA HAYWARD MERRITT. Anna Merritt was the first female member of the Lockport Board of Education. She graduated from the Union School in 1885 and returned to teach there in 1887. Recognized as an exceptional teacher, her career was dedicated to expanding the role of education in the community. She was secretary of New York State's Parent and Teacher Organization and spent 10 years on the public library board.

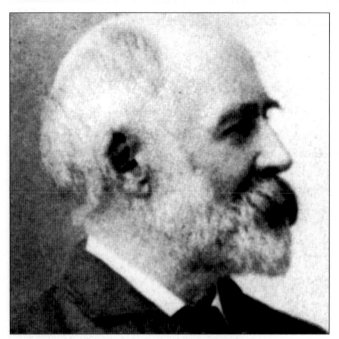

JAMES ATTWATER. James Attwater was the first full-time superintendent of Lockport's Union School. He was appointed in 1854 and served for 11 years. Attwater is viewed as the man who saved the Union School system. He was not simply an administrator, but a respected educator as well. He served as the president of the New York State Teachers Association, was active in local politics, and later became mayor of Lockport.

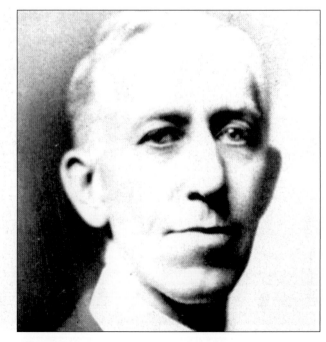

EMMET BELKNAP. Emmet Belknap was a distinguished school superintendent in the area. The middle school on High Street is named after him.

CHARLES A. UPSON. Charles A. Upson founded the Upson Company in 1910 and built it into the world's largest wallboard manufacturer. Arriving in Lockport in 1880 as a boy, he began his business career with a bicycle-repair company he set up with his brother before gaining experience with several paper and board corporations. The first Upson factory was in the old Franklin Mill, next to the canal. The company later moved to Stevens Street.

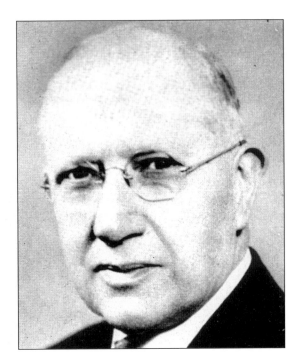

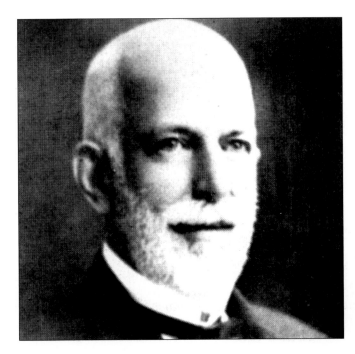

JOHN E. POUND. Twice serving as Lockport's mayor, John Pound was a prominent lawyer in later-19th-century Lockport, rising to become an assistant U.S. attorney. Born in 1843, he was a keen promoter of educational improvements and was president of the city's board of education in the 1880s. An elementary school was named after him. He participated in many philanthropic ventures, notably Lockport's Home of the Friendless, of which he was president.

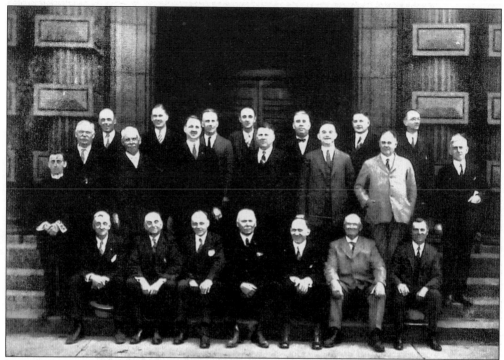

THE EXECUTIVE COMMITTEE OF OLD HOME WEEK, 1925. Every year since 1910, a dedicated group of individuals has organized this homecoming-style weekend in Lockport. The weekend is designed to provide wholesome entertainment for families, celebrate Lockport's history, and welcome back people who have moved away.

WILLIAM MORGAN (1870–1942). As the YMCA's director of physical education in Holyoke, Massachusetts, in 1896, William Morgan invented a team sport that combined skill and tactics without being too strenuous. He called this new game mintonette, but later renamed it volleyball. Morgan was born in Lockport. As a boy, he worked in his father's canalboat building yard. He is buried in Glenwood Cemetery.

JOYCE CAROL OATES. One of America's most vibrant and prolific writers, Joyce Carol Oates was born in 1938 and raised in Lockport. She has set some of her fiction in the area. She began to publish right after graduating from Syracuse University. Her novels include *Them* (1969), *Bellefleur* (1980), *You Must Remember This* (1987), and *Because it is Bitter and, Because it is My Heart* (1990). Her writing also includes poetry, literary criticism, and essays. She has been nominated twice for the Nobel Prize in Literature and is the Roger S. Berlind Distinguished Professor of the Humanities at Princeton University. She has been teaching creative writing at the university since 1978.

WILLIAM E. MILLER (1914–1983). Lockport was the birthplace of a famous political son, William Edward Miller (left), a World War II veteran and a member of the House of Representatives from 1951 to 1965. He ran for vice president of the United States in 1964 on the Republican ticket with Arizona Sen. Barry Goldwater. Miller returned to law after losing to Lyndon Johnson and Hubert Humphrey. He retired to Lockport, living on Willow Street. He is buried in Arlington National Cemetery.

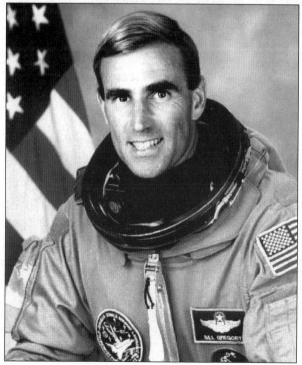

WILLIAM GREGORY. The Great Farini could not have dreamed of the feats of astronaut William Gregory (born in 1957), who orbited the Earth 262 times, traveling seven million miles. Gregory was born in Lockport and graduated from Lockport High School in 1975. He got his bachelor of science degree from the U.S. Air Force Academy in 1979. He became a fighter pilot, flying F-111s, and a test pilot, with 5,000 hours of flying time. NASA selected him for its astronaut program in 1991, and he flew on the space shuttle *Endeavour* in 1995 as pilot on flight STS-67, which created a new mission duration record of more than 16 days in orbit.

Ten

WAR

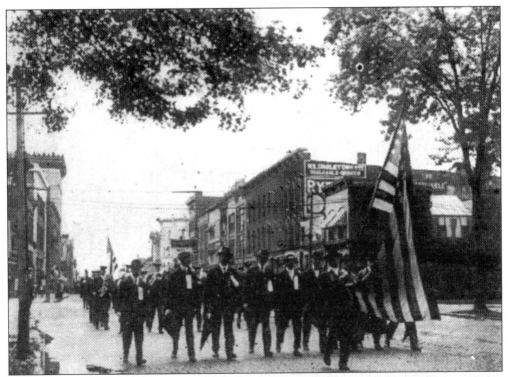

A WORLD WAR I RECRUITING PARADE. A World War I African American regiment is on a recruiting parade through downtown Lockport. The group has reached the junction of Main and Elm Streets. The Farmers & Mechanics Bank building can be seen in the background.

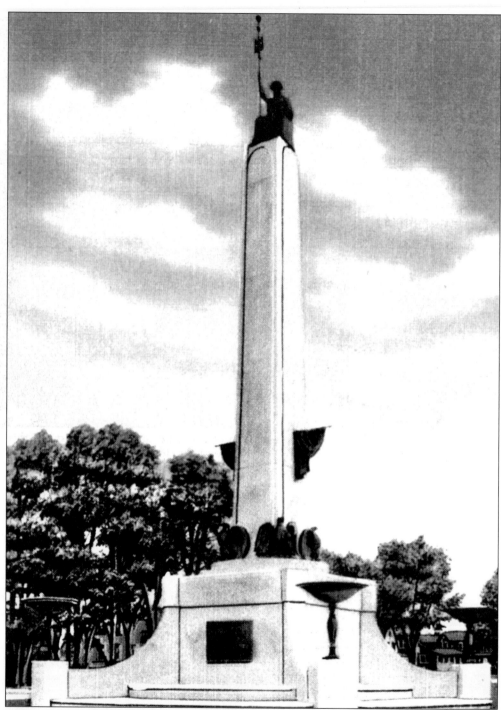

THE LOCKPORT WAR MEMORIAL. Originally called the Soldiers and Sailors Monument, this striking memorial was designed by Lockport artist Raphael Beck and completed in 1930. It has undergone some alteration since this prewar view, and the park where it sits has been considerably embellished. Formerly East Avenue Park, it was renamed Veterans Memorial Park in 1985.

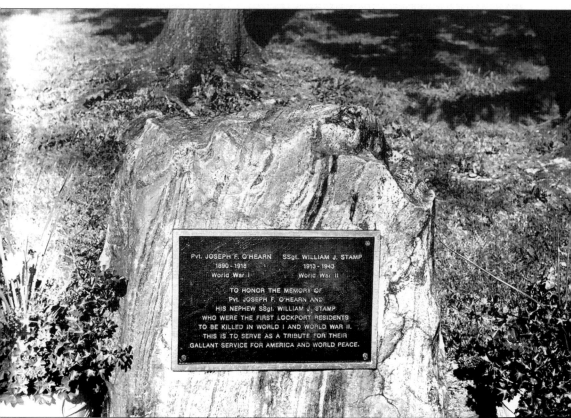

THE O'HEARN-STAMP MEMORIAL. At the eastern end of Veterans Memorial Park sits this poignant plaque, which pays tribute to the first Lockport men killed in World Wars I and II. It is mounted on Lockport marble.

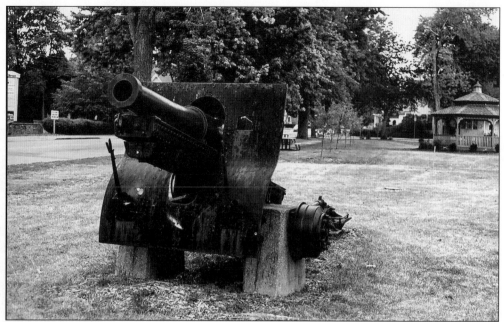

THE CANNON IN IDA M. FRITZ PARK. A sharp reminder of past wars is this World War I cannon that stands incongruously at the busy corner of Park and West Avenues. The city's Navy Marine Club stands nearby on Park Avenue, and it is thanks to the Lockport Devil Dog Detachment of the Marine Corps League that the small park surrounding the cannon has been beautified.

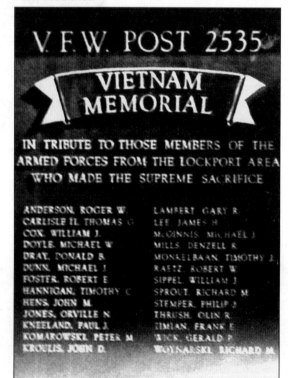

THE VIETNAM WAR PLAQUE. Sadly, further names have been added to the memorial, as Lockport has lost more of its sons in recent conflicts, including the Korean and Vietnam Wars. Lockportians not returning home from the Korean War include Frank Bunchuk, Joseph Buzyniski, Donald Craft, Clarence Fisher, Carl Holthman, Robert Leary, Richard Leyden, Raymond Waters, and William Weland.